THE DESIGN AGLOW
posing guide for
wedding photography

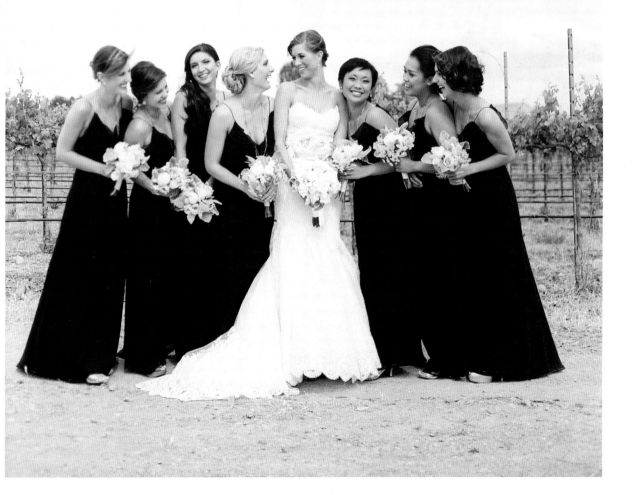

THE DESIGN AGLOW

posing guide for
wedding photography

100 modern ideas for photographing engagements,
brides, wedding couples, and wedding parties

LENA HYDE

AMPHOTO BOOKS

an imprint of the Crown Publishing Group / New York

Photograph on page 1 by Tanja Lippert
Photograph on pages 2–3 by Heidi Geldhauser
 with Our Labor of Love Photography
Photograph on pages 4–5 by Anna Kuperberg
Photograph on pages 6–7 by bobbi+mike

Published in the United States by Amphoto
Books, an imprint of the Crown Publishing Group,
a division of Random House, Inc., New York.
www.crownpublishing.com
www.amphotobooks.com

AMPHOTO BOOKS and the Amphoto Books logo
are registered trademarks of Random House, Inc.

Library of Congress Cataloging-in-Publication
 Data
Hyde, Lena.
The Design Aglow posing guide for wedding
photography : 100 modern ideas for
photographing engagements, brides, wedding
couples, and wedding parties / Lena Hyde.—First
edition.
 pages cm
 Includes index.
1. Wedding photography. 2. Portrait
photography—Posing. I. Title.
II. Title: Posing guide to wedding photography.
 TR819.H93 2013
 778.9'93925—dc23
 2012042972
ISBN 978-0-385-34478-4
eISBN 978-0-385-34479-1

Printed in China
Text design by La Tricia Watford
Photographs by Kat Braman, Mike Belschner,
 Jesse and Whitney Chamberlin, Heidi
 Geldhauser, Jen Huang, Paul and Mecheal
 Johnson, Anna Kuperberg, Lisa Lefkowitz,
 Tanja Lippert, Jessica Lorren, KT Merry,
 Elizabeth Messina, Bobbi and Mike Sheridan,
 and Caroline Winata
Jacket design by La Tricia Watford
Jacket photographs by Elizabeth Messina
 Photography (front) and bobbi+mike
 (back)

10 9 8 7 6 5 4 3 2 1

First Edition

To the hardworking men and women in the photography industry who maintain the standard of excellence we believe in, promote, and stand by.

Your dedication to capturing and preserving moments of joy, growth, and union aids in cataloguing a visual narrative of the world's love stories that will live well beyond this lifetime.

We are here with you, to grow, learn, and advance the pursuit of the fine art of wedding photography.

Thank you for helping to keep photography a prestigious and admirable art form.

Thank you for believing in the beauty of love.

Thank you for continuing to inspire us.

All our best,
Design Aglow

CONTENTS

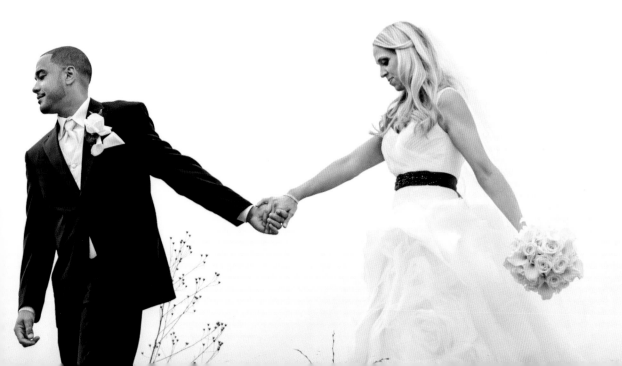

*"Married couples who love each other tell each other
a thousand things without ever talking."*

—Chinese proverb

introduction

At Design Aglow, we have dedicated ourselves to providing tools for flawless presentation, maximum efficiency, and professional success in a visually stunning format since 2006. Our goals: to enhance your wedding and portrait photography, to save you time, to help you increase your sales, and to take your success to a higher level.

This book of beautiful portrait poses for weddings features four chapters of innovative, inspiring, and natural posing ideas for photographing engagements, brides, brides and grooms, and wedding parties at their best. In each chapter you will also find tips for directing your subjects into the poses, helpful lighting information, important technical facts, and additional portrait ideas from the same setups—all from the best photographers in the industry, all presented in a light, conversational tone.

We recommend you use this helpful book in two ways: first, as an easy-to-transport visual guide for inspiration at your sessions; and second, in the studio or at home as a study guide for concepts and techniques to create more innovative portraits.

By following the techniques and tips covered here, you will soon discover how to add emotion and style to your portraits, leading to stunning results you will enjoy right away and that clients will value forever.

We invite you to explore, to expand your creativity, and, most of all, to become inspired by this wide range of simple yet exciting ideas.

Come create fresh, modern, and extraordinary portraiture with us.

—*Design Aglow*

Photo by KT Merry

chapter one

engagements

Engagement photos are an opportunity for your betrothed clients to become more comfortable in front of your camera. This premarital session gives you the chance to showcase the couple's romance in a more casual setting while also creating images for their wedding sign-in book, thank-you cards, and wall portraits (as well as save-the-date cards and invitations, when captured early enough). These portraits also add another dimension to wedding albums, chronicling the couple's story from their engagement to the "big day." Best of all, couples will always remember these special, quiet moments away from the throngs of loved ones and friends.

When photographing couples in love, embrace your multipurpose role as not only artist and documentarian but also location scout and fashion coach. Recommend professional hair and makeup before the session for flawless, lens-ready looks that also allow these vendors prewedding experience with their clients. When scouting locations, think about posing your subjects in front of their future wedding venue, where they first met, or where he proposed.

Encourage the couple to interact with each other to find a natural, camera-worthy rapport. When something they do looks perfect, ask them to hold still or do it again. Throughout the session, keep the mood light and positive, and with a little direction, your couple will look (and feel) their best!

Photo by KT Merry

walkabout

To create natural-looking photographs, put couples in motion and encourage them to take a walk while also interacting with each other. This is a great way to take environmental portraits that include your location in the background, which is especially important when the engagement session is at the couple's wedding venue. Crouch down for a lower perspective; then ask the groom-to-be to put his hands in his pockets and the bride to hold on to his arm as they stroll. For a sweet second take, have her lay her head on his shoulder.

TIP Encourage couples to dress fashionably but also comfortably, since engagement shoots can last upward of ninety minutes and may include a lot of walking, depending on the location.

Golden-hour lighting adds to this dreamy prewedding stroll just before sunset.
85mm F1.4 lens, f/2 for 1/400 sec., ISO 200
Photo by Paul Johnson Photography

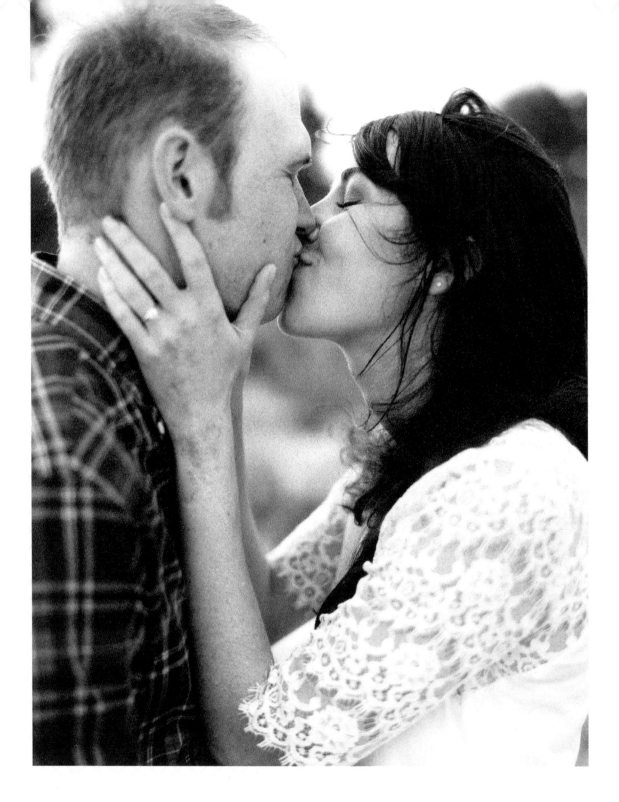

liplock

When you see a natural event unfolding, like an impromptu kiss between sweethearts, don't be afraid to play a little camera cupid. If your couple looks adorable, go with it. Ask for slow kisses, and don't be afraid to ask for as many kisses as you need to capture some with laughter, too. If possible, place your couple in a spot with lovely backlighting to accentuate the warmth between them. For a second capture of a kiss, zoom wider and move behind the groom to show just a little bit of his face peeking out from behind hers.

TIP Instead of asking couples to pose again, ask them to hold still and then move around them yourself, shooting as many quick perspectives of their pose as you can.

Taken at the end of the session, this photo is backlit by the sun's mellow glow as it sets behind the couple.
80mm Zeiss lens, Fuji 400 Neopan film, f/2 for 1/250 sec., ISO 400
Photo by Jessica Lorren

two to tingle

Like an old-fashioned love story, this diptych pairs the gallant, romantic gesture of a man kissing a woman's hand with her delighted response. Start photographing as the moment unfolds; then ask the groom to kiss his bride's hand several more times, framing each shot differently as you go and considering how they will look when displayed together. Be sure to shift height in order to be on the same plane of each subject as you shoot so that the images will look natural side by side. Zoom in close for detail, and then zoom out to grab the entire scene. Afterward, select the two best frames to pair as your diptych.

TIP Remain involved in the moment of each image and shoot a lot, from different angles, but don't push the shutter without purpose. Always think about how you are framing each image before you take the shot.

Photographed on a partly cloudy day, this couple was placed under an overhang to allow bouncing light from the ground to illuminate the area. 80mm Zeiss lens, Fuji 400 NPH film, f/2 for 1/60 sec., ISO 400
Photos by Elizabeth Messina Photography

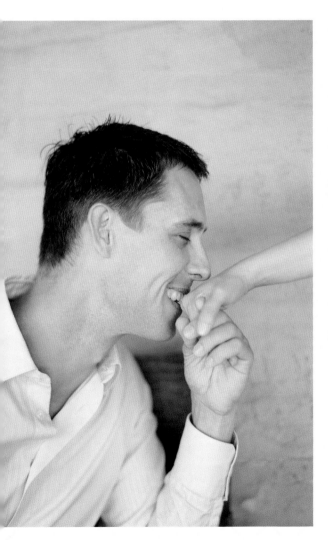

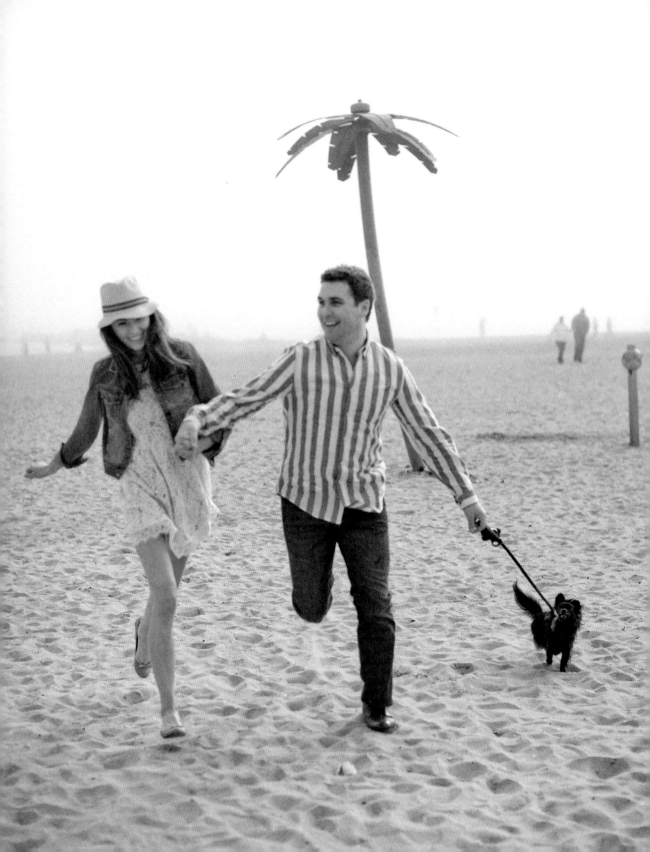

get a
move on

Images incorporating movement capture the joyous feeling of a couple embarking on a journey together. Start by taking a few photographs of the couple seated on the ground or a bench. Next, have the groom pull the bride up to her feet. If they are playful, have them run or walk toward the camera while holding hands so that you can capture their interaction as they move. Step backward as safely as possible to show them coming toward you before they zip past the camera. To avoid blur, always remember to use a faster shutter speed of at least 1/500 sec. with moving subjects.

TIP Try to include a few naturally occurring details from the environment in the frame to help tell the story. Here, the sand provides visual interest, the palm tree lends depth, and the dog working to keep up adds playfulness.

On this bright, overcast day, the sand acted as a natural reflector. Overexposing the image slightly created a distinctive, high-key look.
50mm F1.2 lens, f/2 for 1/8000 sec., ISO 800
Photo by Jen Huang Photography

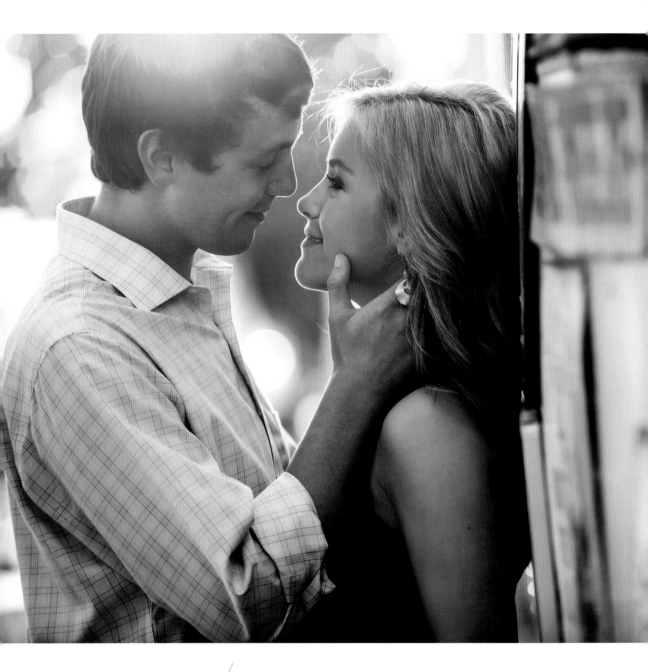

This photo was taken about twenty minutes before sunset
to take advantage of the low sun and its dazzling solar flare.
70–200mm F2.8 lens, f/2.8 for 1/320 sec., ISO 200
Photo by Paul Johnson Photography

special
places & faces

With exquisite magic-hour backlight, thoughtful composition, and a selective depth of field, this pose highlights a glowing sense of intimacy between a couple with ties to a special location. In this image, the venue was a favorite vacation spot of the couple, but the same approach will work in any meaningful location. Ask the bride to lean against a sturdy wall, and tell her betrothed to approach her and kiss her. When he embraces her face, capture her natural reaction, focusing on the couple while including the location in the rest of the frame. For a second capture, turn the camera to vertical, and ask the bride to look in your direction. Often, the transition from a fresh, intimate look at each other to a direct gaze at the photographer creates compelling expressions for the camera.

TIP While directing your couple to ensure the best captures, be sure to also give them space to be natural. Authentic reactions tend to create the best moments, and the couple will better connect to the image knowing it was a natural (and not prompted) response.

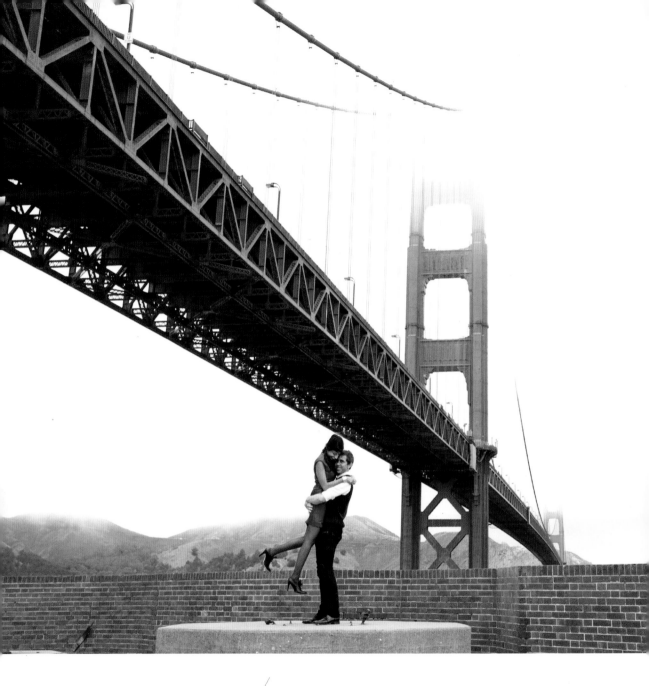

As seen here, fog can be a wonderful lighting tool, acting as a giant softbox to cast even, diffused light on the scene.

16–35 mm F2.8 lens, f/9 for 1/250 sec., ISO 400

Photo by Anna Kuperberg

embracing
the location

Diagonal lines and a woman jumping into her groom's arms make this an environmental image begging to be printed large for high-impact art that the couple will enjoy forever. Ask about a spot special to the couple, perhaps where the proposal took place—in this case, a rather famous bridge. No matter where the location, frame the scene to make the architecture or environmental element the main feature, framing the couple positioned smaller in the scene. For a second capture, photograph upward toward the couple, hand in hand, as the bridge (or feature) frames them from behind and above.

TIP Whenever possible, shoot in the early morning or late afternoon. During these times, the sun is soft, and the light is especially flattering, bathing clients evenly without harsh shadows.

on the street
where you live

Part of telling a couple's story includes documenting locations that speak to who they are together. One location that has meaning for most couples is their own street and neighborhood, so be sure to scout areas near their home for textures and colors. Show creativity with cropping and perspective. For variety, move in for close captures of the couple and their interactions; then go wide to show their home in the background. Ask them to turn toward each other, whisper a secret, give a little smile, giggle, or kiss. Front steps can also present unlimited posing possibilities and add a lot of visual interest.

TIP Consult with your couple before the session to help them plan outfits and suggest props. The better prepared everyone is before the shoot, the more terrific the outcome.

Late-afternoon sun (one to three hours before sunset) eliminates a considerable amount of harsh light, while the open shade of a building smoothes out unwanted highlights.
80mm Zeiss lens, Fuji Pro 400H film, f/2 for 1/1000 sec., ISO 200
Photos by KT Merry

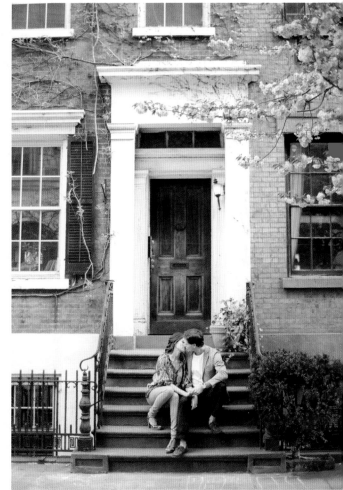

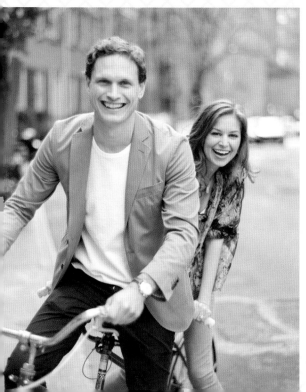

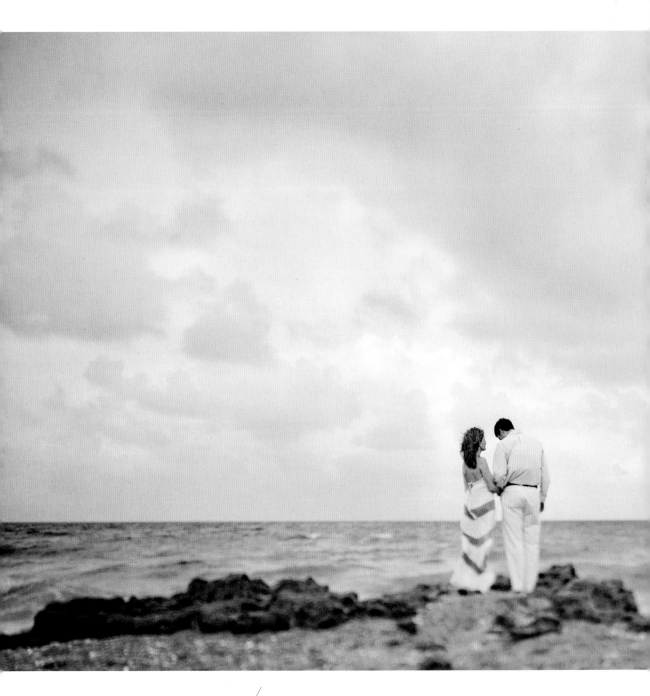

In this photo, taken during the last hour before sunset, the sun is coming from behind the photographer, sliding in and out of the clouds.

35mm F1.4 lens, f/4 for 1/100 sec., ISO 800

Photo by Kat Braman

big & small

If you are in a location with a wide vista or open sky, add a big dose of negative space by showing your subjects small within their environment and allowing the eye a place to rest. Stand approximately twenty feet from your couple and shoot from just below eye level. Ask the couple to face away from the camera while focusing on each other. In the image shown here, a blur was added in postproduction; a tilt-shift lens can achieve the same effect in-camera. Some additional shots from the same setup: have them turn, with their arms around each other, and face the camera; direct them to hold hands and spread apart, creating an M shape; finally, ask the groom to put both hands in his pockets with the bride's arm looped through his for a snuggle, and move in closer for a tighter shot.

TIP Start a portrait session with tight shots so that you can talk to your subjects, use humor, and create a comfortable atmosphere while also showing them how to interact with each other in front of the camera. Once they're comfortable, back up to shoot wider images.

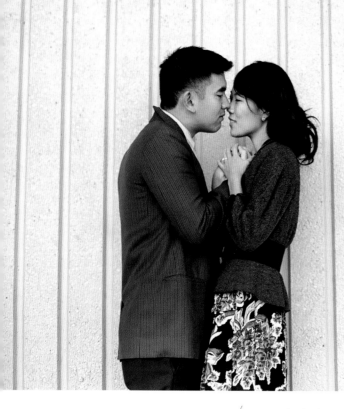

Here, the building behind the couple shields them from the
sun, while another light-colored building across the street
provides a nice, natural bounce of light.

35mm manual focus AIS lens, Kodak 400CN film, f/4 for 1/125 sec., ISO 250

Photo by Tanja Lippert

timeless romance

Combine a textured, light-colored wall; an off-center composition with plenty of negative space; and warm sepia toning for a vintage, cinematic feel. Place the bride and groom standing with their hips joined while she pulls his hands to her heart. To avoid double chins, have them push their chins out toward each other or slightly toward the camera. For additional captures, grab the couple holding hands as he leads her through the location, or step back and photograph various full-length poses of the pair. Sepia toning accentuates the portrait's sense of timelessness, while the building's shade creates the perfect opportunity for flattering, even light—even closer to midday.

TIP Consider the scene, the couple, their clothing, and the light, and ask yourself whether the image you are making works all together. For example, the timeless quality of sepia toning might not work well if the couple is wearing very modern clothes or you are photographing in a gritty, urban environment.

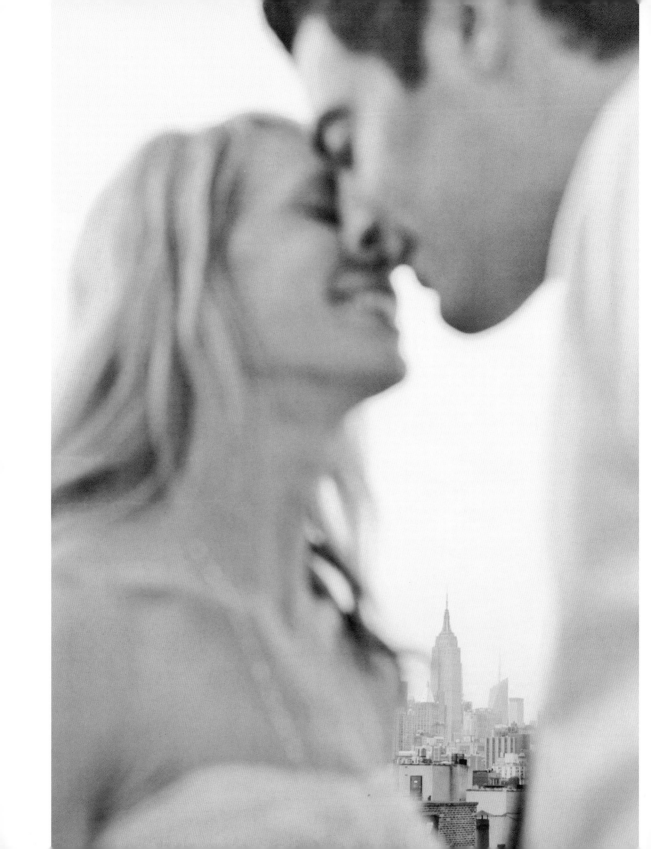

love in
soft focus

This pretty, close-up posing option features the couple in soft focus while highlighting a skyline, monument, building, or other landmark near and dear to their hearts in the background. Crouch down and shoot from a low perspective to raise the background up behind the subjects. Use selective focus to keep the building or monument sharp in the background, while the kissing couple is soft and less defined in the foreground. For a second shot, shift your focus so that the couple is sharp and the background element blurred.

TIP Let your subjects know when they will not be in focus in a picture. Often, they will relax and loosen up, allowing you to capture more natural expressions.

The rooftop beneath this couple boasts light-gray asphalt, which reflected sunlight nicely onto the subjects, eliminating dark shadows under their chins.

35mm F1.2 lens, f/3.5 for 1/400 sec., ISO 640

Photo by Heidi Geldhauser with Our Labor of Love Photography

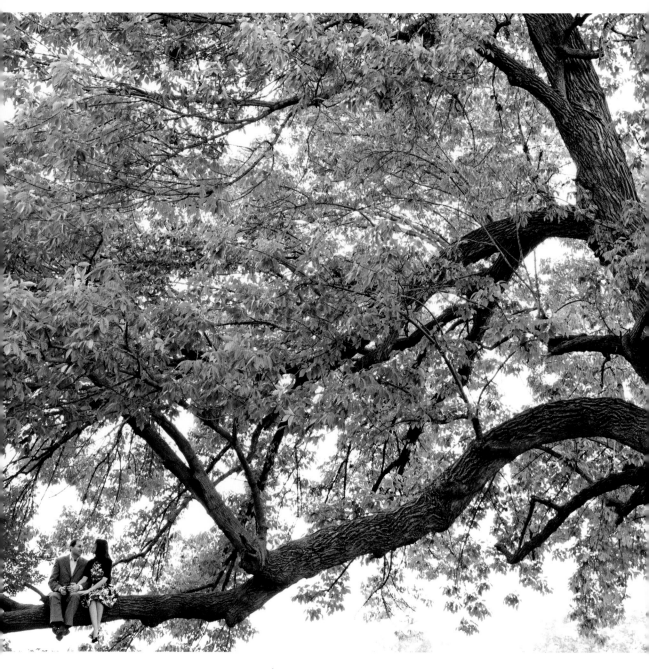

Here, the photographer increased the ISO to compensate for a
heavily overcast day, while the tree's canopy blocked light
from three sides, allowing for a softly frontlit portrait.
35mm F1.4 lens, f/4 for 1/160 sec., ISO 2500
Photo by bobbi+mike

creative crops

Always look out for trees, natural landmarks, sculptures, and other elements that can become extraordinary with a little creative cropping. In this image, the crop and angle make it look as though this perched pair is suspended in a tree very high in the sky, though their feet are actually only a foot or so above the ground. After shooting a wide version of this pose from a low angle, stand up, get closer, and shoot a fun detail of just their legs and feet. Then grab a wide-angle lens (here, a 35mm F1.4) and shoot a full-length portrait of them snuggling in the tree, continuing to frame out the ground to maintain the illusion of them being high in the sky. Can't go out on a limb? No problem. This pose can be grabbed with the couple sitting on a low brick wall, too.

TIP While you can't always control the timing of each event on the wedding day, for an engagement/portrait session you have total jurisdiction. Scout your location in advance, and determine the best time to shoot; then schedule your session accordingly.

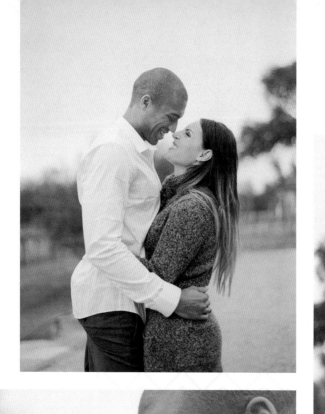

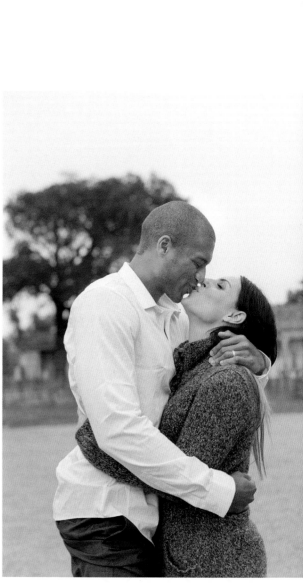

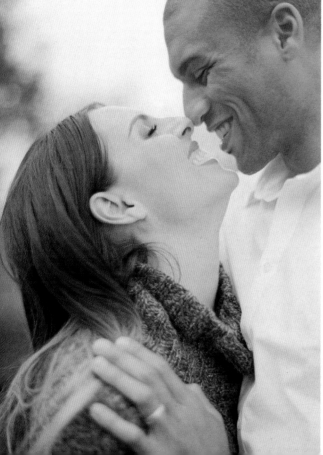

subtle shift

Slight variations of a pose or a moment—and sometimes the smallest shift in perspective—can make the difference between a good image and a truly magical one. Start by having the couple face each other for a sweet, more formal composition. Then ask the groom to squeeze the bride with his arm wrapped around her, pulling her in for a kiss. As they pull apart and laugh, move in closer for a more tightly framed shot.

TIP Have a shy client? Put down your camera and chat for a while. Create a positive environment that will help your clients feel comfortable. Then start shooting details of the pair holding hands or sharing a small moment, so these first moments don't involve a timid subject looking directly into the camera right away.

This photographer exposed for the shadows to get soft, even lighting.
80mm Zeiss lens, Kodak Portra 800 film, f/2 for 1/60 sec., ISO 800
Photos by Elizabeth Messina Photography

picture the embrace

This artful embrace ensures that all arms and hands remain in the frame, even after you crop at the couple's waists. Instruct the groom to keep the bride cozy in his arms. By having her arms wrapped around his, you can display her hand lovingly adorned with an engagement ring. Since he is standing slightly behind her with his chin out on the same focal plane, both of their faces will be sharp. Consider starting with a full-length portrait to showcase the entire environment, followed by a waist-up capture like the one shown and then close-ups and details of hands and feet.

TIP Hugs are perfect for tight crops, but don't be afraid to zoom out to capture more of the environment, especially if the venue is particularly distinctive or if a moody sky beckons an upward capture.

The light on this stormy afternoon was flat and low; overexposing slightly made the couple pop a little more.
80mm Zeiss lens, Fuji Pro 400H film, f/2.8 for 1/90 sec., ISO 200
Photo by Tanja Lippert

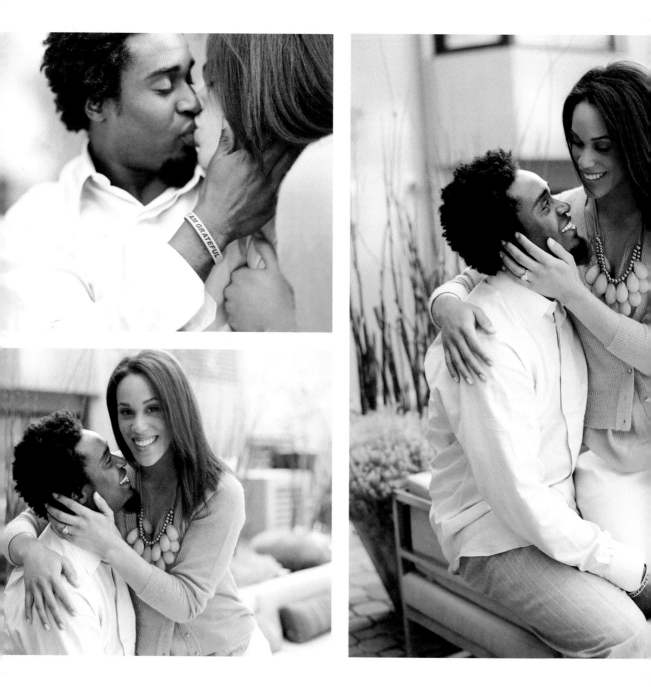

slice of life

Let your couples interact naturally, allowing each photograph to effortlessly convey their real relationship. In this example, the groom sits on the arm of a chair, and the bride is placed on his leg. Once they get into position and playfully interact, fine-tune their poses by suggesting she put her hand on his cheek (to show off her ring, of course), and then have him do the same. The next portrait might be of them exchanging romantic glances on the couch or an environmental frame of the location.

TIP For the most successful images, make sure every detail included makes sense and feels consistent, from the clothing to the location to the couple's body language. Here, the couple's colorful clothing and easygoing manner mesh well with bright pops of background color framing them on either side.

A light-colored building reflected sunlight to fill this patio with natural luminance.
80mm Zeiss lens, Fuji Pro 400H film, f/4 for 1/125 sec., ISO 200
Photos by Tanja Lippert

connected
& relaxed

For this casual, full-body pose, have the couple face each other with the groom in a slightly open stance. Ask the bride to shift her weight onto her far leg and move the near leg back, rest her hand in the groom's, and toss her head back as she looks at you. After this image, zoom in closer for a more traditional portrait of the couple smiling at the camera.

TIP Many couples may want an image for an engagement announcement in the newspaper, so be sure to take at least one straightforward portrait that shows both of their faces clearly and on the same plane.

**The shade from a bank of palm trees
provides even lighting late in the afternoon.**
80mm Zeiss lens, Fuji Pro 400H film, f/2.8 for 1/500 sec., ISO 400
Photo by Jessica Lorren

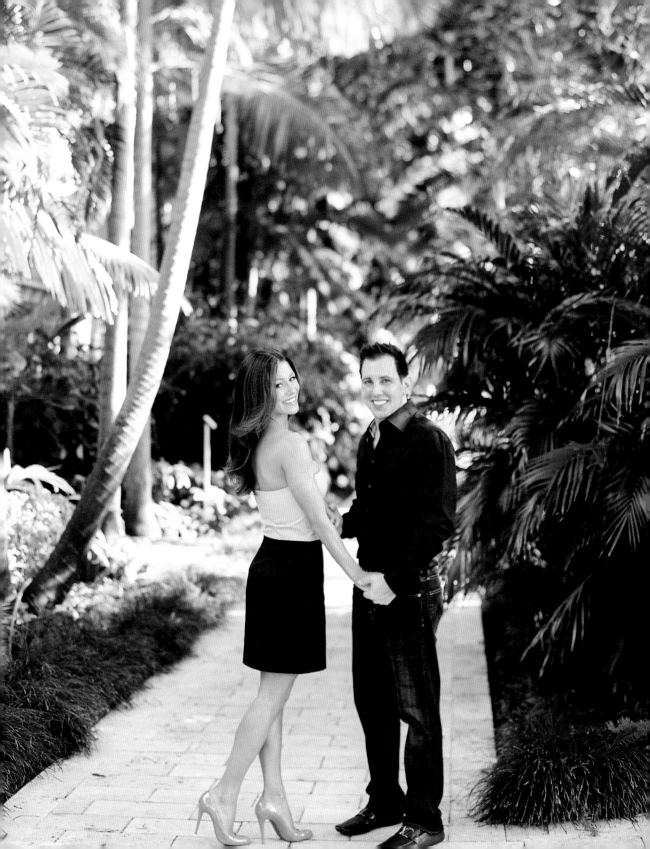

sneak peek

For a glimpse into a seemingly private moment, position yourself to shoot upward through some brush (or other obstruction, including architecture) to create an illusion of intimacy. Instruct your couple to hold hands, place their foreheads gently together, and look into each other's eyes. For a second frame, swing around and shoot from the other side, capturing the two together with a tighter crop. Then ask them to move closer, with the groom nuzzling the bride's ear. Finally, take a few pictures with her looking right into the camera.

TIP Once your subjects are in position, be sure to double-check their jawlines and arms for the most flattering angles. It's easier to take a few extra seconds while shooting than it is to try to fix problems later in postprocessing.

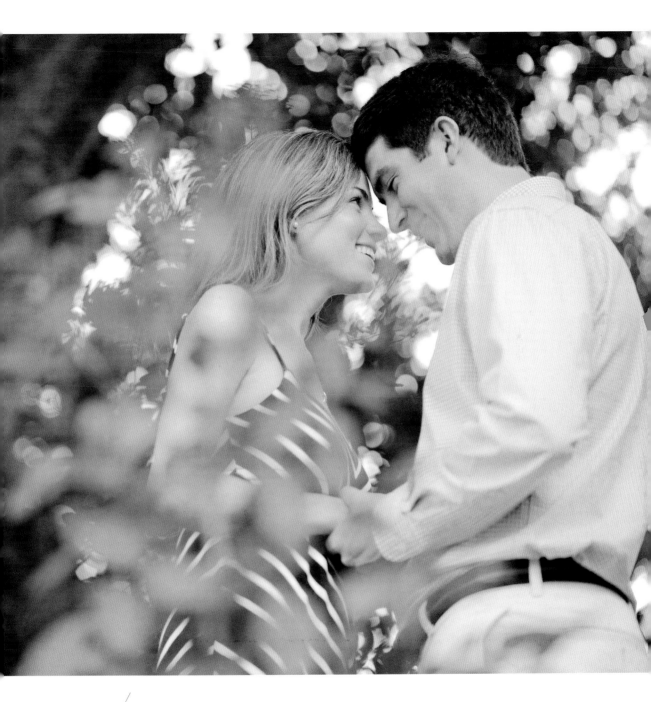

The light in this image, taken in open shade about an hour before sunset, originated from behind the photographer's right shoulder.

80mm F1.8 lens, f/2 for 1/160 sec., ISO 200

Photo by Kat Braman

cozying up

If a groom is reticent about being photographed, place him in a comfortable situation that removes the emphasis from him and places it on the couple instead. For this snuggling, seated pose, make sure the bride-to-be's legs are angled away from the camera to mirror her partner's body (and to prevent photographing up her dress or shorts). If the groom is really nervous, he can look at his bride and smile while she looks into the camera. For a second shot, move in closer for a very tight frame of their faces in the same pose.

TIP When guiding your clients in choosing a clothing color palette for their session, consider the hues of the environment where the session will take place. In the portrait shown here, the natural denim look mimics the blue of the sky and nearby ocean. In the mountains, a textured, layered look with forest green and brown earth tones would be rustic and comfortable.

In this capture, taken on a beach on a slightly overcast day, clouds and sea mist provided a heavenly haze, while the white sand acted as a reflector, bouncing the soft, diffused light right back onto the subjects.
80mm Zeiss lens, Fuji Pro 400H film, f/2.8 for 1/500 sec., ISO 400
Photo by Jessica Lorren

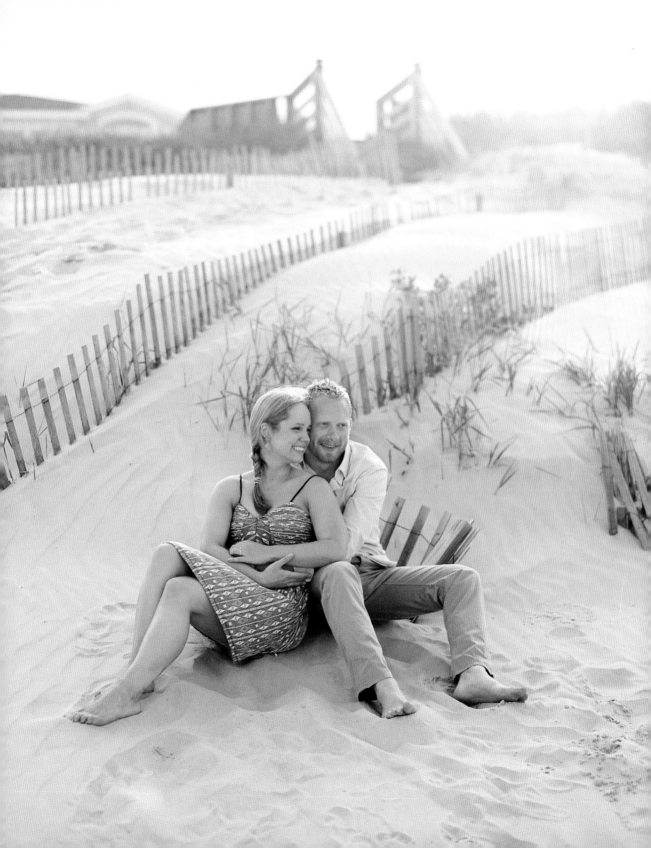

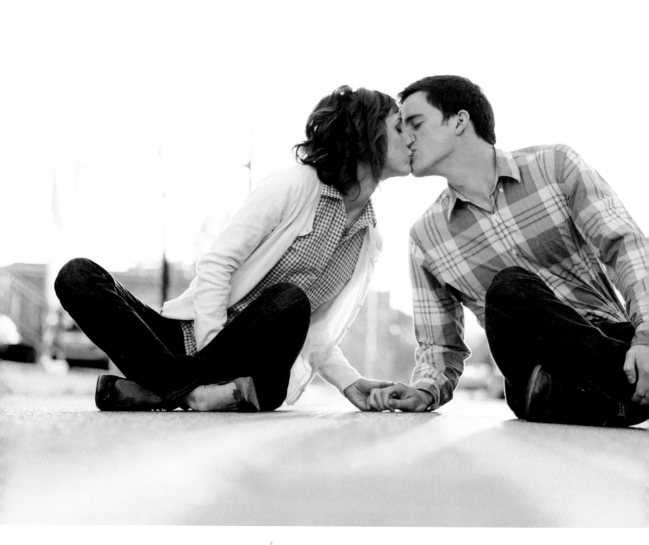

This photo was taken at the very end of sunset.
The sun had just dropped behind the subjects,
its light creating a red glow and a high-key sky.
50mm F1.2 lens, f/2.2 for 1/800 sec., ISO 200
Photo by bobbi+mike

sweet
symmetry

This touching photograph showcases connectedness, balance, and simplicity, all with a casual vibe. Find a quiet street with great backlighting, and ask your subjects to sit beside each other in the center, one on each side of the center lines. You want to center yourself and the subjects for symmetry, with the center lines leading directly to the couple. Lie down to get the camera at ground level for a unique perspective as well as to avoid a horizon line running directly behind the subjects' faces, and ask them to lean in toward each other for a kiss. For a second shot, zoom in for a tightly cropped vertical shot of just their torsos, faces, and hands. You can also stand up, move a few feet back, and photograph from a higher perspective, cropping out the sky.

TIP When choosing a street for this pose, note that aged, light-colored asphalt can be a great, natural reflector for backlit images.

body language

Framing portraits without faces is not the norm, but it can be a fresh way to highlight body language that speaks volumes about the closeness between two people. Ask the pair to sit on the ground and cuddle together. Place the groom first; then pose the bride nuzzled into him. Have them lean toward each other to remove any space between them. Photograph from above, with the grass as the background, for a refreshing and interesting perspective.

TIP It is often easier to pose the groom-to-be first, especially for "on the ground" captures. Women tend to be more flexible and will have an easier time positioning themselves in response to their partner.

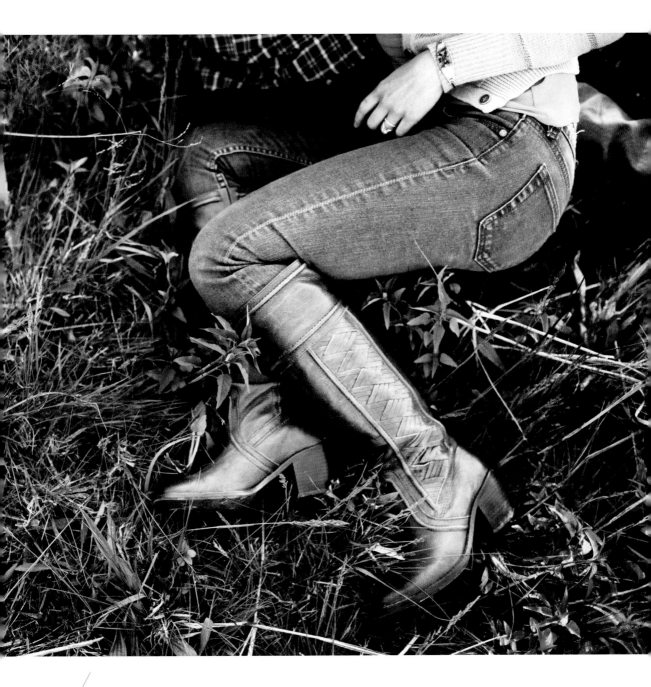

This couple was captured in open shade about two hours before sunset.
35mm F1.4 lens, f/2 for 1/500 sec., ISO 600
Photo by bobbi+mike

swept away

This natural, dynamic pose speaks volumes of the couple's love and affection. Start by getting in front of the couple and prompting them to walk together toward your camera. Ask the groom to sweep up his bride as you continue to photograph them. For a follow-up shot, turn the camera to vertical and come in for a tighter crop of their torsos as they embrace. If clients prefer to sit, photograph from above as they share an embrace for a flattering capture.

TIP It's always a good idea to have a neutral blanket or quilt on hand so that clients can sit on otherwise moist, dirty surfaces without soiling their clothes.

This shot was taken on a beach just after the sun had set below the horizon. Gorgeous light remained in the sky and was reflected by the sand as a warm glow.
85mm F2.0 lens, f/1.4 for 1/320 sec., ISO 720
Photo by Paul Johnson Photography

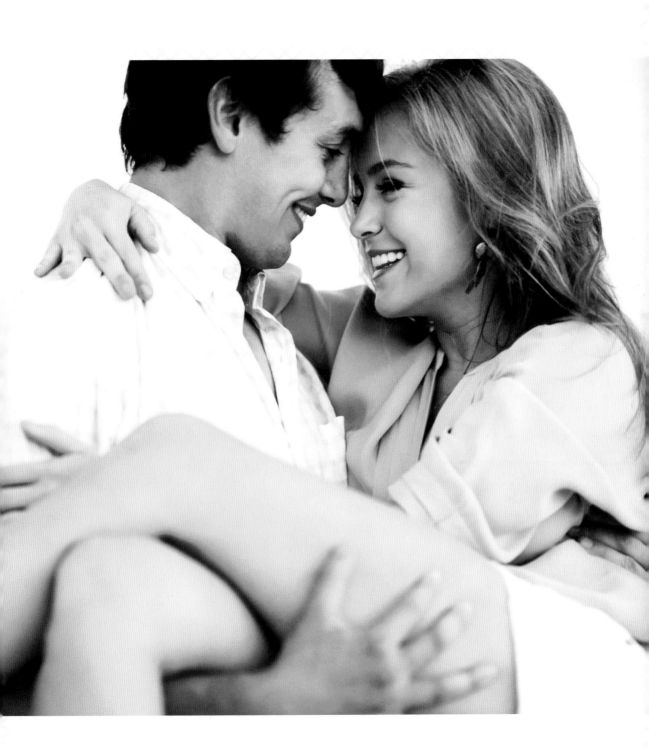

private moment

Framing an interesting element in the left third of the image, with the couple in their space in the right two-thirds, creates a feeling of intimacy, as if you have glimpsed a private moment. Have the subjects sit with their heads together and arms and legs intertwined. Ask them to lean into each other and whisper something sweet, ensuring that their hands are engaged. Position yourself higher than your subjects to frame both them and the element.

TIP When attempting a complicated composition like this, put the couple in position, and then ask them to simply interact with each other so that they aren't focusing on you or waiting for the snap of the shutter.

Dark clouds over this shady courtyard created a low-light scene, making a black-and-white conversion the right solution to prevent noise.
80mm Zeiss lens, Fuji 400 Neopan film, f/2.8 for 1/250 sec., ISO 400
Photo by Jessica Lorren

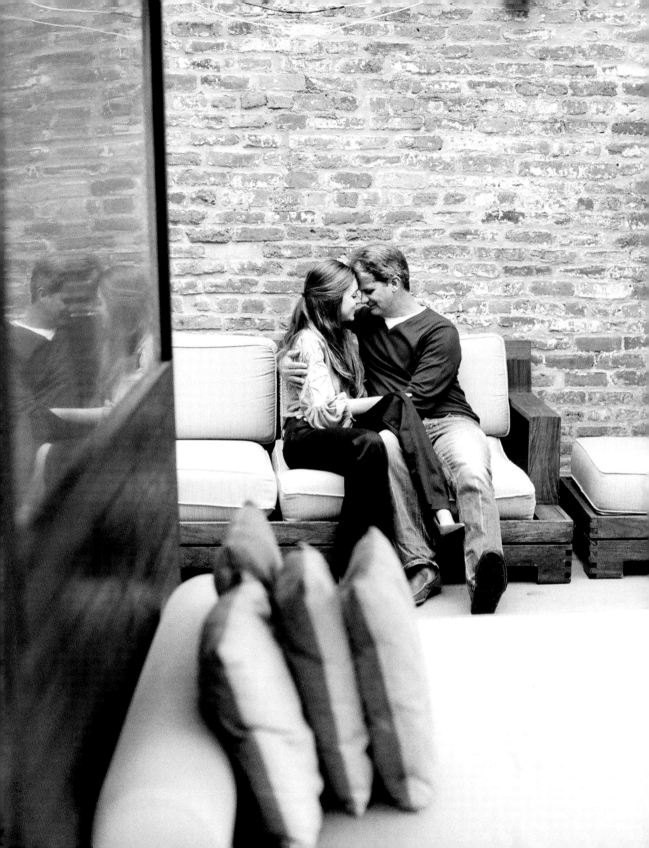

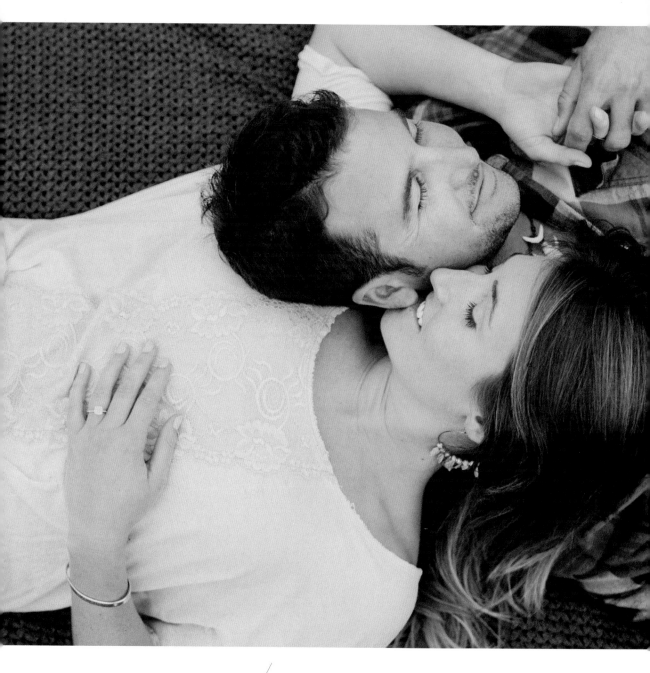

This shot was taken in overcast, natural light about two hours before sunset, the clouds naturally diffusing and softening the sun's rays.

35mm F1.4 lens, f/2 for 1/160 sec., ISO 200

Photo by Kat Braman

cute & cuddly

This perspective of a couple lying down reveals soft smiles and a sense of playfulness. Ask your couple to recline so that their feet point in opposite directions, with her head on his shoulder, mouth leaning in toward his ear. Ask them to link hands, close their eyes, and talk about a silly or funny memory. Stand on a stepladder or chair to photograph from a high vantage point. For more shots from the same vantage point, have them both look at the camera or into each other's eyes. Finally, capture them both facing the same direction with her snuggled into the crook of his shoulder.

TIP Most people feel more comfortable in front of the camera when they know what to do with their hands. Consider having a subject play with a bit of grass, a lock of hair, the edge of a shirt, or the hemline of a dress.

from the top down

You can capture this delightfully clean, minimalistic composition anywhere there is a higher vantage point, whether the couple below is in a boat or on the ground, a sofa, a bench, or an interesting staircase. After photographing them at their level, get above them and frame a shot looking down. Have them sit close and snuggle up with their hands touching. Next, grab a tighter angle, and ask them to go in for a kiss but stop just short. Finally, ask them to look up for another great, quick portrait.

TIP For natural smooches without awkward fish faces, ask couples to relax their mouths and just touch lips.

Dappled midday sun necessitated positioning the couple with their heads slightly down to achieve even light on their faces.
35mm F1.4 lens, f/2 for 1/800 sec., ISO 200
Photo by Kat Braman

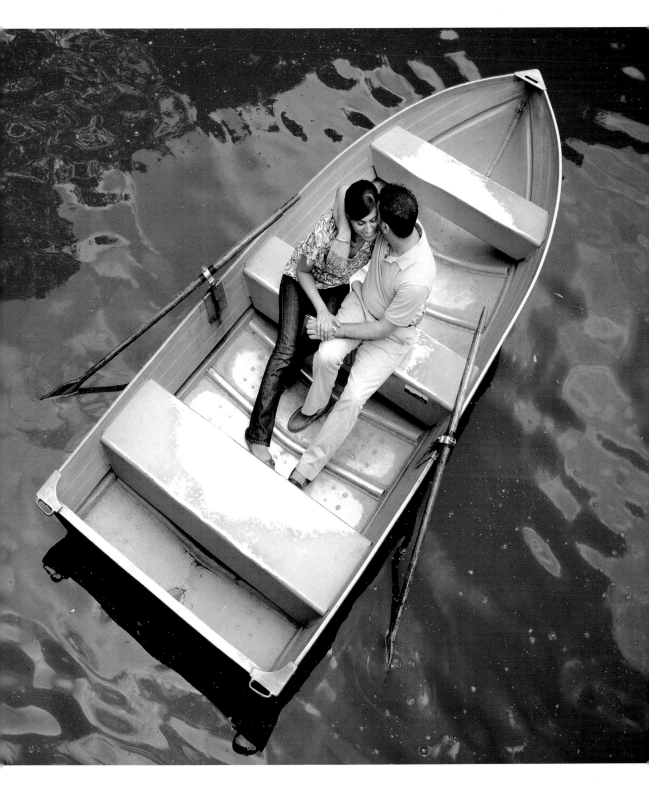

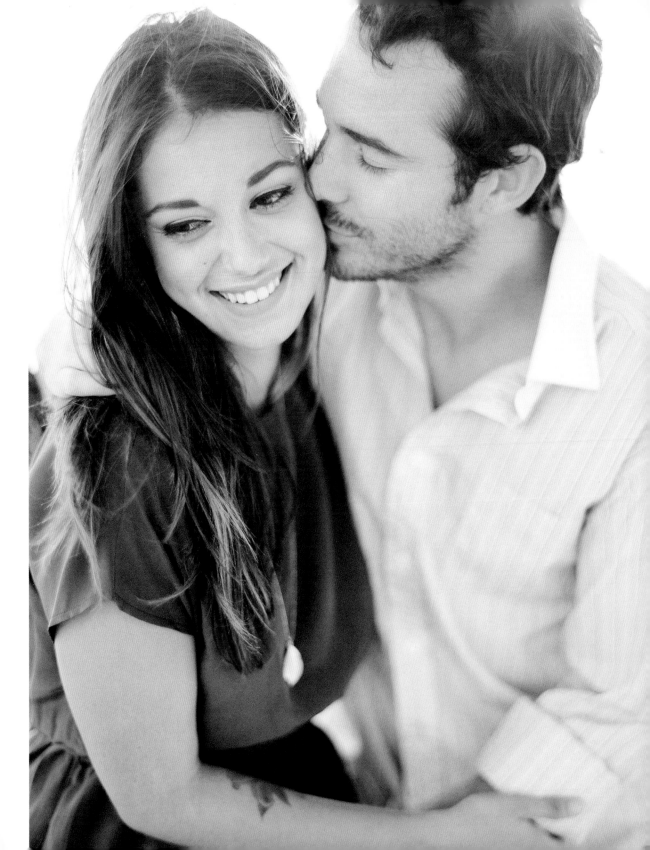

great grins

Capturing genuine smiles from your clients is always the goal. For a surefire way to elicit a natural smile from the bride, ask the couple to sit down and get close. While keeping your focus on the bride's face, instruct the groom to gently kiss her cheek, and then wait for her smile, which will appear almost immediately. Next, have the couple turn toward each other, and ask him to kiss her. For another grab, direct them to sit cheek to cheek and look toward the camera.

TIP Set yourself up for success by placing your couple in a spot with beautiful light so that you can take several wonderful images in a snap. If you start shooting and realize that the light isn't working, don't be afraid to move them, transitioning to a spot with better light while keeping things upbeat with meaningful, constructive praise.

Soft, warm, even backlighting contributes to this tender portrait, photographed in a golden field.
80mm Zeiss lens, Fuji Pro 400H film, f/2 at 1/500 sec., ISO 200
Photo by KT Merry

silhouetted kisses

This silhouetted pose is sexy, fresh, and modern. If you have an interesting architectural element to use as a frame, place the couple in relation to the element (here, a parking garage). Get far enough away, and shoot up at the couple to include lots of sky and create a cleaner, more minimalistic composition. For more fabulous captures, ask the couple to face the camera straight on, and then have them turn their heads to look at each other.

TIP When shooting a silhouette, keep space between the couple to avoid the forms merging into an unidentifiable, dark shape. Pay very close attention to what that shape looks like before pressing the shutter.

To capture this silhouette, taken on an overcast day in an open parking structure, the photographer exposed for the natural light outside of the garage.
35mm F1.4 lens, f/2 for 1/1250 sec., ISO 400
Photo by Kat Braman

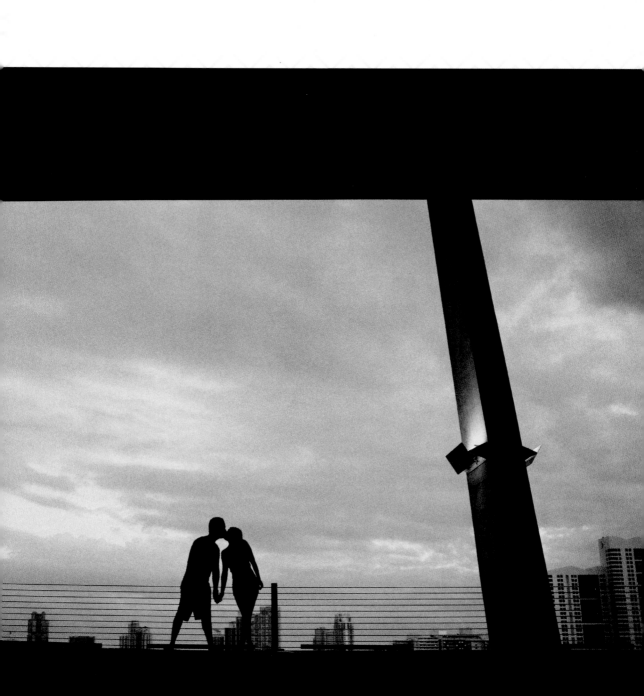

brides

Working with the most important figure of the wedding—the bride—is both thrilling and challenging. Whether it's a late bouquet arrival or a rainy day, what can go wrong often will. Thankfully, solutions abound.

Get to know your bride and work with your environment to capture the most flattering portraits. Take advantage of available lighting and simple backgrounds, positioning her to look her best in every shot. When weather permits, capture a lovely portrait of the bride in light shade next to a luscious, blooming tree. When indoor images are a must, consider a mix of ambient lighting from windows, glass doors, candles, and strobes for stunning effects.

Subtle posing shifts can make a big difference. Have the bride lift her chin slightly to avoid a double chin. Placing hands on hips and turning slightly makes a waist look smaller. Placing one foot slightly forward softens the hip and looks more natural. Elongating her neck ever so slightly might feel unnatural to her, but it dissuades unsightly shadows.

Throughout your session, provide plenty of time and patience for interruptions from well-meaning friends and family. It's important that your bride feels in control and relaxed, so portray a cheerful countenance in spite of any setbacks.

With practice, you will come to find that photographing the bride is an exciting challenge, as you capture a lovely lady on her most joyous day yet.

Photo by KT Merry

out of sight

This pose is powerful because of what you *don't* see, conveying the emotion and anticipation of a wedding day while keeping the bride's actual face and expression private. It is also a great image for your portfolio, as the obscured face allows viewers to see themselves in it. Center the bride in a window, facing away from you, and ask her to raise her arms so that the light flows through her sleeves and dress. Expose for the darkest shadows to avoid a silhouette and nurture a luminous glow. Combine this image with a detail shot (such as of the bride's shoe, the ornate embroidery on her gown, or the delicate trim on her veil) and a more traditional bridal portrait to create a stunning triptych.

TIP There is no need for complex prompts. Simple instructions such as "Hold still" or "Turn and look at the camera" allow brides to move and react in a way they would naturally, resulting in beautiful, organic poses that show their personality.

Available light from outside frames the bride evenly, while exposing for the darkest area in the room creates a luminous glow around her.
80mm Zeiss lens, Fuji 400 NPH film, f/4 for 1/30 sec., ISO 400
Photo by Elizabeth Messina Photography

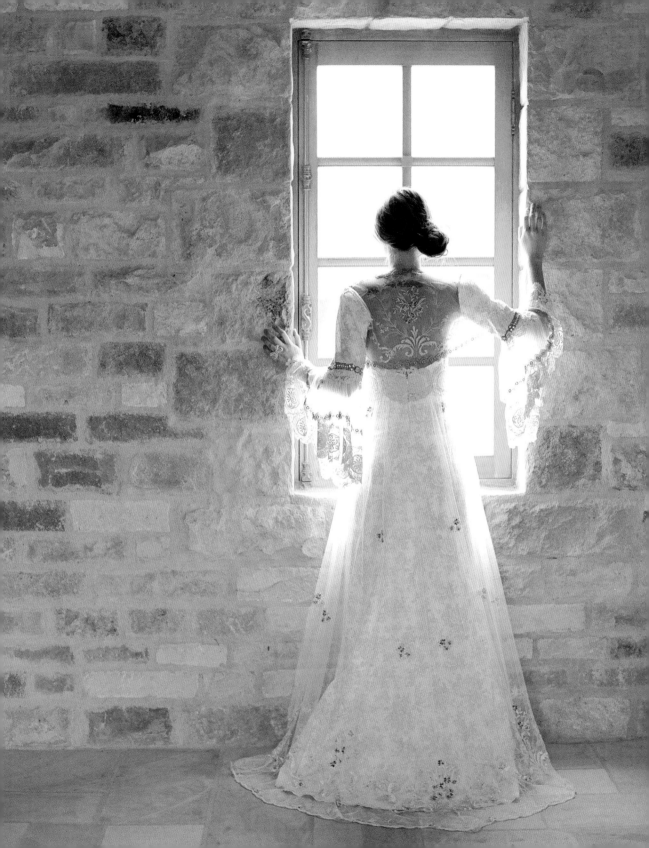

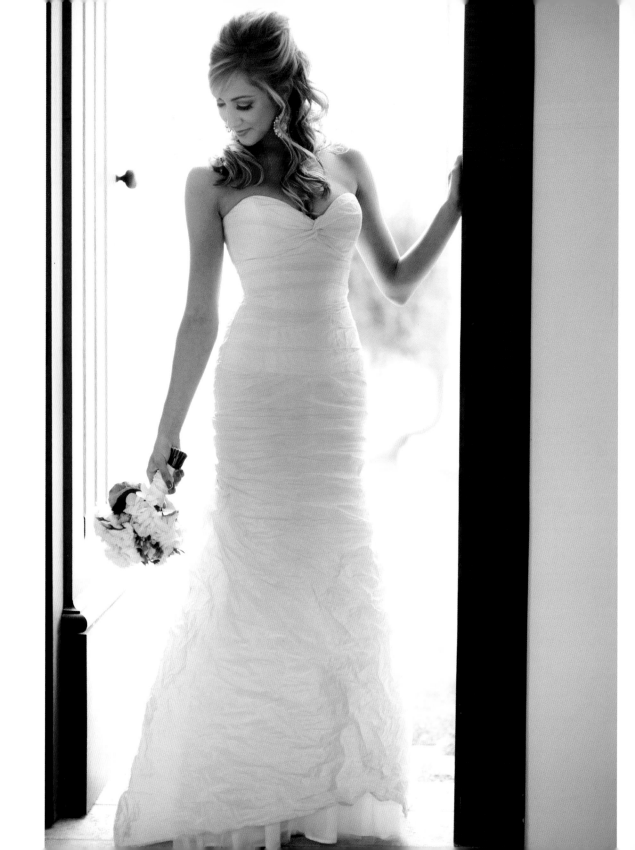

baby's got backlight

This lovely portrait combines a flattering pose with glowing backlight that caresses this bride's dress and flowers with faint shadows. Find a backlit doorway, and instruct the bride to approach the opening using her left hand as a brace against the door frame. Ask her to let her flowers fall casually to her side and look down at the bouquet. To follow up, zoom in tighter for a heavenly head shot. For an inspired third portrait, ask her to release her hand from the doorway and look your way, as if to ask, "What's next?"

TIP For most backlit portraits, you'll want to expose for the darkest shadows on the bride's face or dress to avoid a silhouette and create a luminous backlit glow.

The all-natural lighting in this backlit doorway creates soft, lovely shadows on the bride's gown.
85mm F1.4 lens, f/2.8 for 1/320 sec., ISO 2000
Photo by Paul Johnson Photography

unique chic

For a glamorous head shot that shows off the bride's hairstyle and accessories, grab a close crop of her top half at eye level. To get that natural smile, ask her to think of her groom just before you snap the shutter. Next, get a picture of her seated and leaning forward on her elbows, her chin resting on one open palm, and dangling her flowers from the other arm. For a third capture, turn her to the side, and take a photograph while she's rocking her shoulder and flirting a little.

TIP Always try for at least one over-the-top stunning image of the bride; it will usually end up being her most frequently shared image, especially online.

Midday sunlight filtering through a window illuminated the white walls in this room, perfect for reflecting light onto the bride.
Left: 85mm lens, f/1.2 for 1/100 sec., ISO 2000; right: 50mm lens, f/4 for 1/100 sec., ISO 2500
Photos by Milou + Olin Photography

full-on flair

Keeping cool under pressure, especially during the big day, is easier said than done. To help relax and pose an anxious or excitable bride, ask her to put her hands together softly, tilt her head slightly, and put her weight on one leg (shifting the hip away from the camera) to create a flattering S-curve. For a second capture, move in for a close-up of just her hands to showcase the engagement ring.

TIP To make a bride's waist appear smaller, have her place her hands on her hips and let the light peek through between her waist and elbows.

Early-afternoon light filtering through a thick covering of trees keeps this beauty looking cool.
80mm Zeiss lens, Fuji Pro 400H film, f/2 for 1/250 sec., ISO 400
Photo by Jessica Lorren

glowing
recommendation

Be sure to take a few head shots of the graceful bride in the light of a nearby window once her makeup and hair are freshly prepared (and before she enters the swirling excitement of her ceremony). Stand near a window, and ask the bride to walk toward the window from about ten feet away. As she moves past you, have her stop and look your way. For a second image, back up quickly to take a full-length portrait of her dress.

TIP While it's best to experiment with a variety of perspectives and angles, be sure to also capture some eye-level photographs, which can be extremely flattering and intimate.

Sidelight can be more dimensional and interesting than harsh, straight-on light. Here, having the bride turn to look at the camera illuminated her face with more dimension.
85mm F1.4 lens, f/2.8 for 1/320 sec., ISO 2000
Photo by Paul Johnson Photography

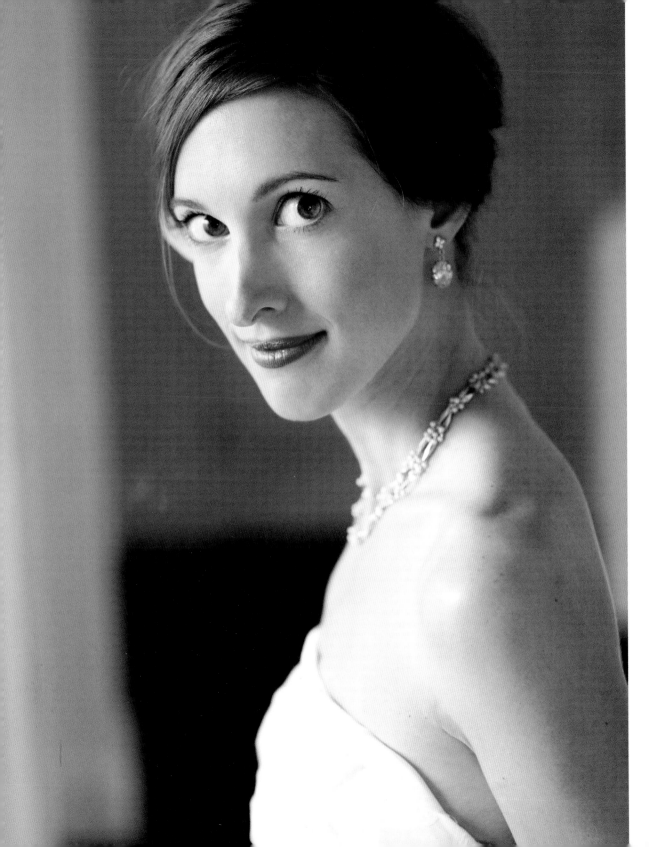

Light spills in from outside and bounces around
this white room to reflect back on the subject.
35mm F1.4 lens, f3.5 for 1/800 sec., ISO 400
Photo by Anna Kuperberg

grand entrance

For a dramatic doorway pose, locate a doorway with beautiful backlight, and direct the bride into a flattering S-curve by having her place one foot slightly forward and shift her weight onto her back foot. A subtle bend in the arms and a tip of the head feels natural. Light will spill in around her, emphasizing her form and making her look sleek and slender. Next, capture a vertical shot of just the bride in the entryway. Finally, have her lean in the door frame, looking into the space.

TIP Ask the bride to look at a specific object (of your choosing) to camera right for the best angle.

beneath the veil

This dreamy, feminine pose lets soft window light illuminate the bride's makeup and hints of details (such as her necklace and hair). When shooting with window light, ask your bride to stand with one shoulder right next to the window and photograph up close, making use of the soft sidelighting. Ask the bride to cast her eyes down and embrace herself for a relaxed portrait. For a second photograph, back up to capture the whole frame of the window and her entire form.

TIP As the bride gets ready before the wedding, watch how the window light in the room shifts on her face as she moves. Then once her hair and makeup are ready, you can place her strategically for the most flattering images.

Muted natural light softens the details and flatters this bride's face.
80mm Zeiss Lens, Fuji Pro 400H film, f/2 for 1/30 sec., ISO 200
Photo by KT Merry

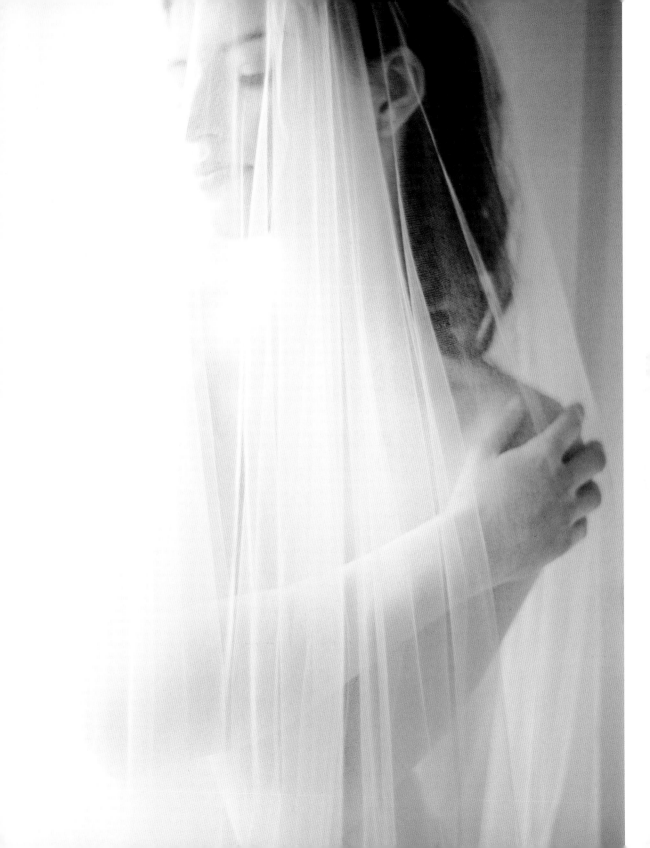

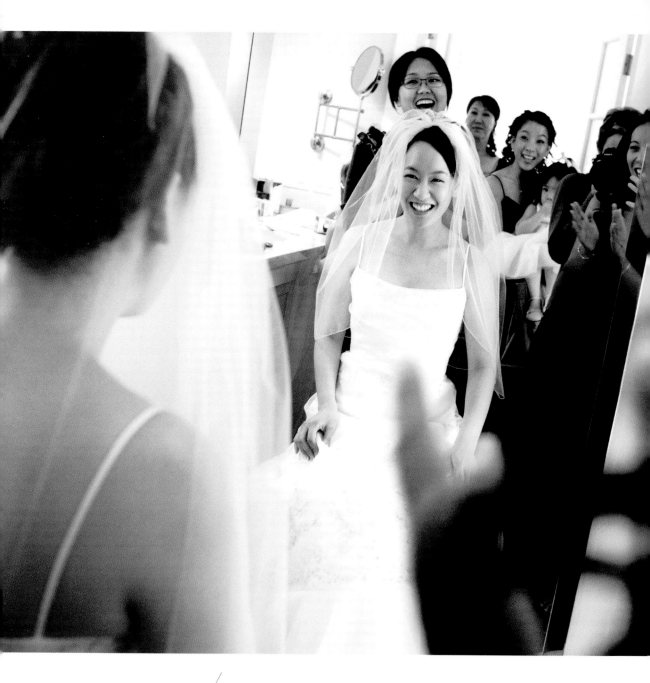

A mix of natural and incandescent light in this bathroom
adds a gorgeous glow to an already brilliant bride.
24mm F1.4 lens, f2.8 for 1/125 sec., ISO 1000
Photo by Anna Kuperberg

time
to reflect

Portraits with mirrors and reflections give viewers a peek into an intimate world. For a spontaneous-feeling, photojournalistic shot, place yourself in the right spot to capture the bride's reflection but not your own (here, the photographer stands on a chair facing—but not in—the mirror, behind the girls), and tell the bride, "Look at how beautiful you are!" Adding "Isn't she, ladies?" will provide an enthusiastic round of claps, smiles, and cheers, all reflected in the image. For an alternate version, perform the same dialogue with just the bride, or in the company of her maid of honor or mother.

TIP Converting to black and white eliminates color distractions and keeps the focus on the most important subject (here, the bride and her emotions). For this image, a little tilt of the camera provides extra dynamism.

angling for success

Place the bride with her side facing a window; then stand on a chair or step stool for a sweet, flattering angle from above, zooming in tight to eliminate distractions in the background. In the image shown here, the photographer placed the bride and then asked her to don her jewelry, knowing she'd naturally turn her head toward the window as she put on her earrings. Use this same flattering downward angle to grab a formal bridal portrait, a capture of the bride holding family heirlooms (something old, new, borrowed, or blue), or a picture of the maid of honor putting the bride's shoes on her feet before the ceremony. This angle is especially flattering for the more voluptuous bride.

TIP Even in a dark hotel or church, pulling a bride over to a window and raising your ISO setting will produce more flattering results than artificial lighting.

Natural sunlight spills into a bright room and illuminates this bride as she prepares for her ceremony.
80mm Zeiss lens, Kodak Portra 800 film, f/2.0 for 1/60 sec., ISO 800
Photo by Jessica Lorren

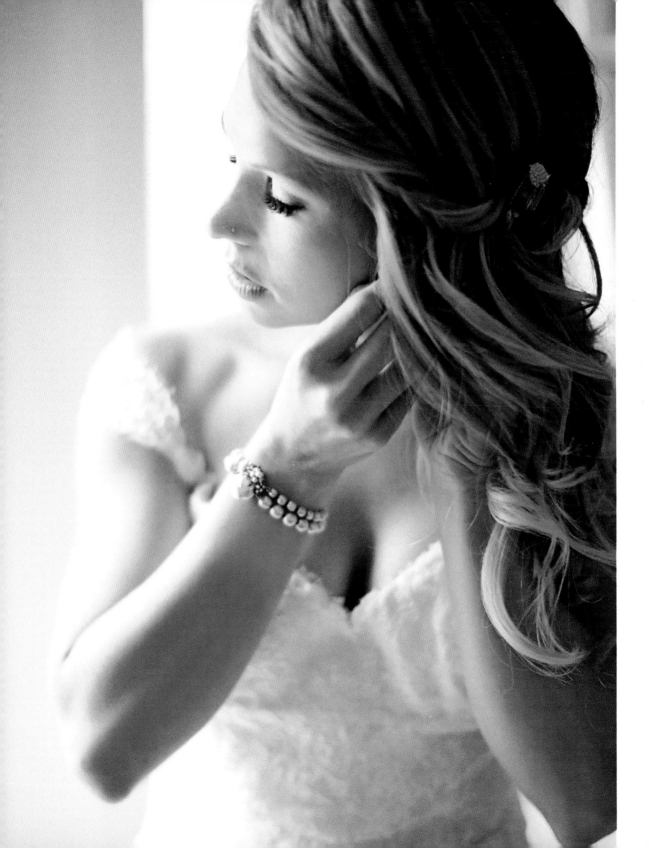

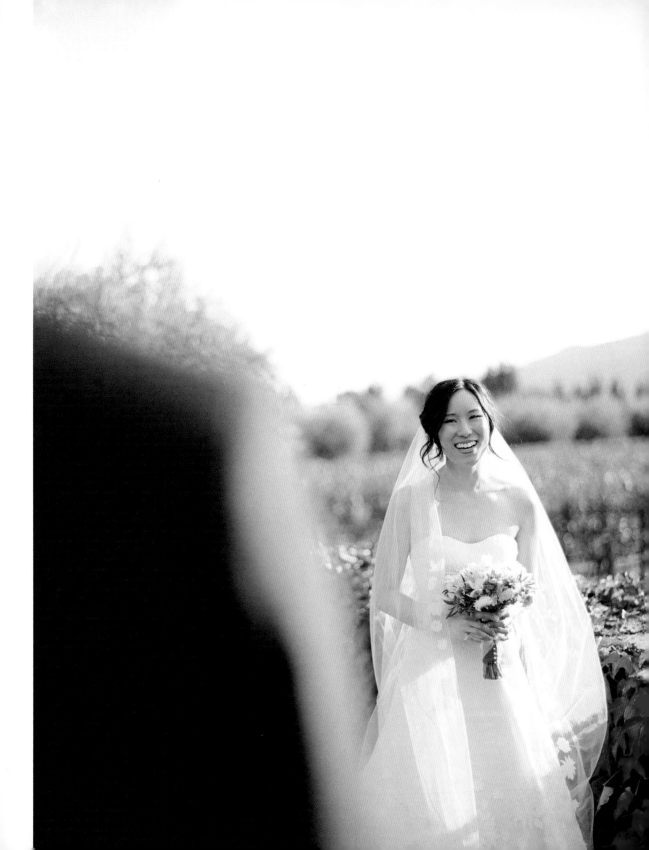

looking at love

For a fresh, unexpected portrait, position the groom just in front of the camera's view and peek around his shoulder to capture the bride. Not only will this help take the bride's focus off the camera but the resulting image will provide a glimpse at a moment of pure, unadulterated joy between the couple. Whisper to the groom that he should tell his bride how lovely she looks or share a romantic memory; then snap the shutter as she responds. For a second capture, ask him to make her laugh.

TIP Scheduling a private "first look" portrait session with the bride and groom before the ceremony puts couples at ease and ensures they won't miss a moment of their reception or cocktail hour.

Early-afternoon sun behind the bride bounces off a light-colored gravel road in the foreground to cast lovely light on her face and a soft glow around her hair and dress.
80mm Zeiss lens, Fuji Pro 400H film, f/2.8 for 1/250 sec., ISO 200
Photo by Tanja Lippert

timeless
glamour

This dazzling diptych evokes the classic glamour of an earlier age. For the first image, use a very shallow depth of field and angle downward to focus on the veil, carefully lining it up so that the edge lies parallel with the edge of the frame. Next, ask the bride to stand facing a window and look straight into the light as you photograph from the side for a beautiful, moody profile. Dramatic lighting, clean and simple posing, and a high-contrast black-and-white conversion create these timeless looks, especially for brides who choose classic styles in their gown, veil, and hairstyle.

TIP Look for interesting wallpapers and textures in the "getting ready" room of the hotel or venue for photographic opportunities.

A window directs dramatic light onto this classic beauty.
Left: 85mm F1.2 lens, f/1.2 for 1/640 sec., ISO 640;
right: 85mm F1.2 lens, f/2.8 for 1/160 sec., ISO 1000
Photos by Anna Kuperberg

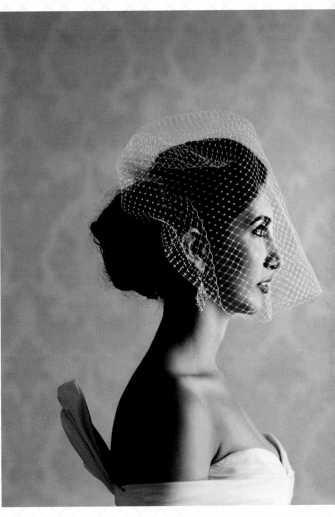

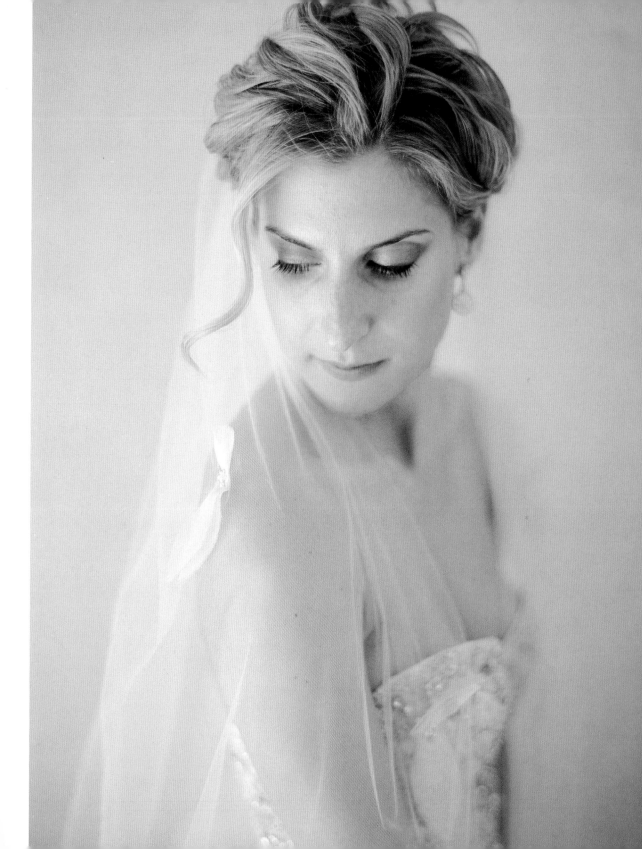

serene glow

This thoughtful pose creates a glowing, beautiful portrait. Place a chair sideways in front of a window with soft, diffused light. Ask the bride to sit at the edge of the chair to prevent slouching and turn her head toward the camera, while also looking down at a point toward the floor (such as a low table). To ensure a serene expression and give the portrait a feeling of quiet contentment, ask the bride to take a deep breath and then exhale to relax her facial muscles.

TIP Veils are fantastic for softening any areas you don't want to accentuate, such as a wall behind the bride or shadows under her chin.

This blushing beauty was captured in open shade with bright sunshine coming in from camera left.
80mm Zeiss lens, Fuji Pro 400H film, f/2 for 1/1000 sec., ISO 200
Photo by KT Merry

almost ready

This unexpected portrait is a great addition to "getting ready" captures and can be successful with almost any special undergarment or hair-and-makeup garb. Position the bride in front of a window that's covered with sheer or light curtains. Ask her to stand with her feet together and glance casually to the side while outstretching her arms and fingertips to show off her waist. Looking like a butterfly, she will be backlit by gently masked window light, creating a near-silhouette where veil meets window sheers. Stand far enough back to capture her entire figure, and expose for the shadows. For a second image, move quickly to the bride's side and photograph her profile, using the window light as sidelight.

TIP Always close the sheer curtains in the room. They help create a clean backdrop (hiding ugly door and window frames) and diffuse harsh light.

Shooting in a dim room lit with only subtle window light, the photographer used a high ISO and metered for the bride's shadow. 80mm Zeiss lens, Ilford 3200 film, f/2 for 1/250 sec., ISO 1600
Photo by KT Merry

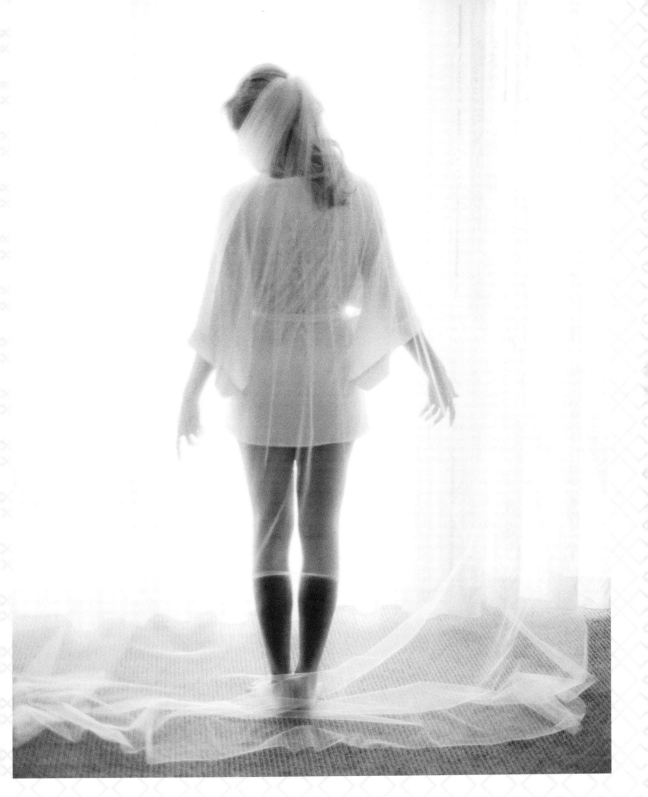

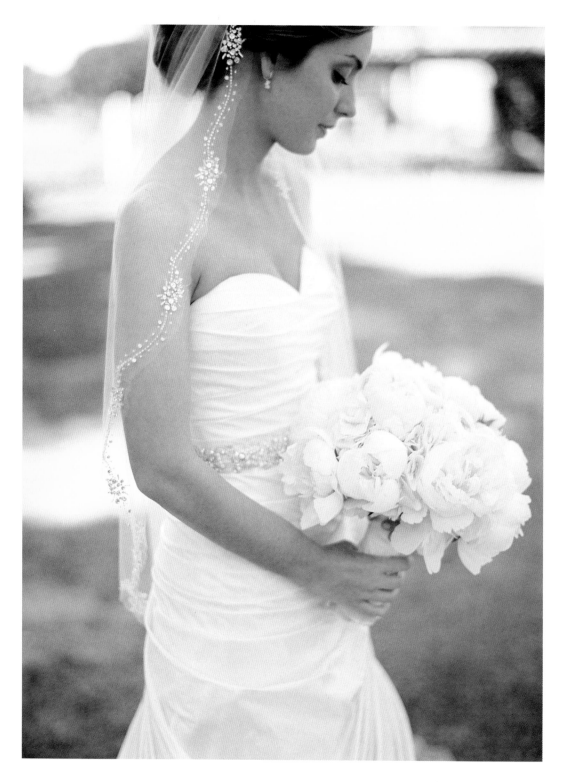

fresh perspective

Both detail shot and portrait in one, this fresh pose captures the bride while also showcasing her bouquet, gorgeous gown, and delicate veil. After you take a traditional bridal portrait, ask the bride to relax her arms and hold still; then walk around to her side, and ask her to cast her eyes down at her bouquet. Frame the shot to give the bouquet center stage. Make sure her veil is resting softly and not completely fanned out for a more natural look. Next, zoom in for a tight photograph of just her hands holding her flowers.

TIP Ensure that you don't miss the most important images for a bride by asking her to create a shot list of must-have photographs before the wedding, such as portraits with old roommates or her flower girl.

For this photograph, captured midday in the shade of a giant banyan tree to the left of the frame, metering for the shadows ensured a sweet, even exposure that maintained the detail in the bride's dress, veil, and bouquet.
80mm Zeiss lens, Fuji 400 film, f/2 for 1/1000 sec., ISO 400
Photo by Jessica Lorren

and . . . action!

A dynamic departure from typical bridal portraits, this action pose has a captivating and cinematic flair. This type of portrait is best taken after the bride has walked down the aisle and you've captured her pristine, formal portraits; at this point in the day, a little dirt won't be devastating. Instruct the bride to walk swiftly away from the camera, and then ask her to stop and look back at you for a beautiful, wide capture. Feel free to keep the image intentionally soft, as here, to further convey the sense of movement. For a second take, have her walk swiftly toward the camera.

TIP Make the most of a stunning location with plenty of wide shots. In a less attractive venue, shoot tighter and focus less on the background.

As light faded toward the end of the day, the widest aperture possible was used to capture this environmental shot.
80mm Zeiss lens, Fuji Pro 400H film, f/2 for 1/250 sec., ISO 400
Photo by Jessica Lorren

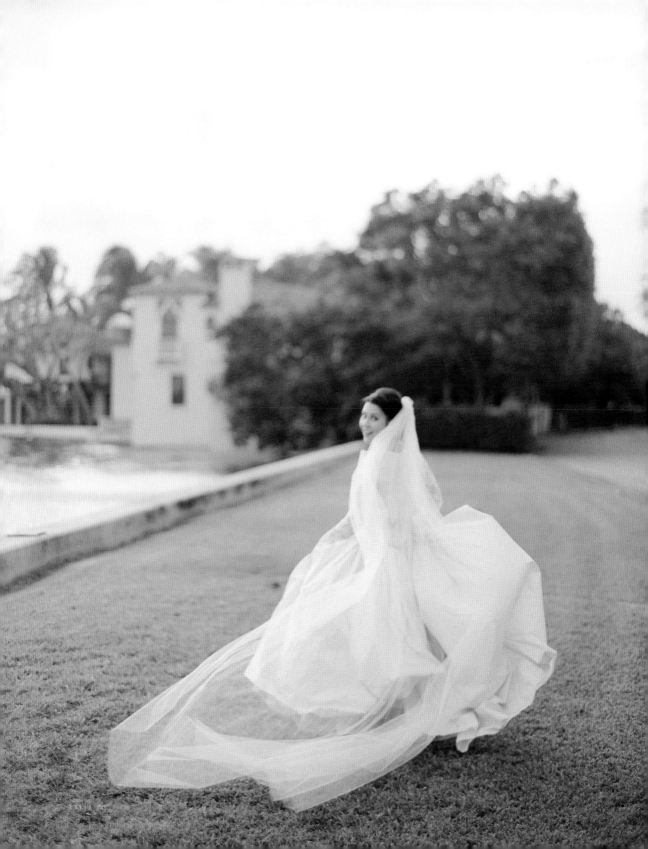

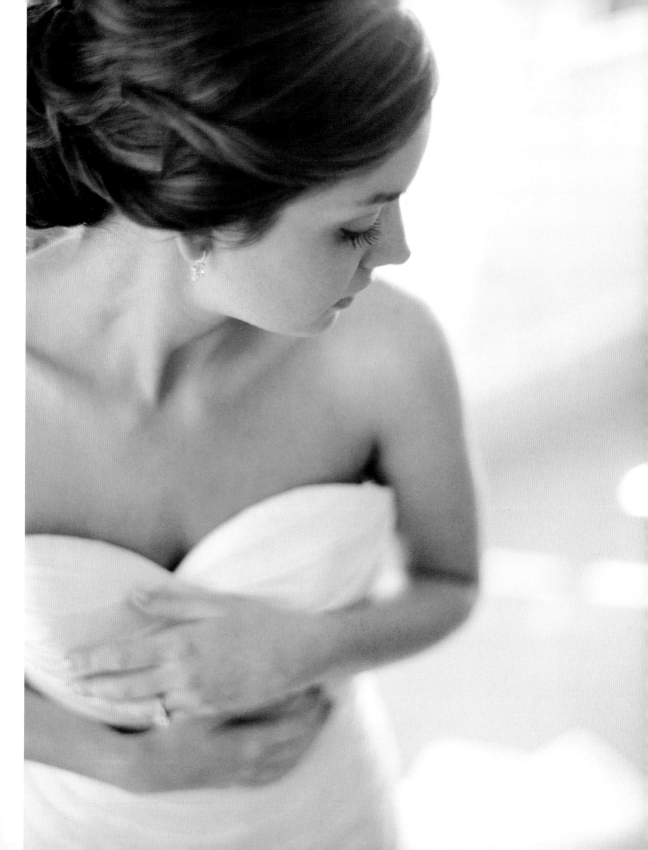

candid camera

Phenomenal bridal portraits don't always require careful posing direction, especially since candid photographs are an equally meaningful part of the wedding-day story. Put yourself in a position to take perfect pictures without asking anything of the subject. Ask the bride to stand near a window as she gets into her dress; then stand on a step stool or ladder to shoot some candids as the bride and her entourage interact naturally. Here, the maid of honor is behind the bride, buttoning up the gown. Even without any direction, the clever framing and the from-above perspective turn a candid moment into a beautiful portrait.

TIP Use a shallow depth of field to draw the eye to desired features (here, the bride's face and collarbone) while de-emphasizing others (in this case, the floor).

Here, the photographer shot at a downward angle to diffuse the harsh, directional light spilling in through the windows.
80mm Zeiss lens, Kodak Portra 800 film, f/2 for 1/60 sec., ISO 800
Photo by Jessica Lorren

complete package

To capture a classically flattering full-body pose, turn the bride gently to the side to capture her dress, bouquet, veil, and train. Ask her to bend her elbows and neck slightly, angling her eyes down toward her flowers. Use a shallow depth of field and a darker, contrasting background to accentuate the bright pop of white from her beautiful gown.

TIP If you're confronted with dappled sunlight spilling through the trees, play with it. Here the bride's train ends gently in a shape that mirrors the pools of sunlight on the ground around her.

The open shade of a tree is the perfect place for portraits during the sunniest part of the day.
80mm Zeiss lens, Fuji Pro 400H film, f/2 for 1/1000 sec., ISO 400
Photo by Jessica Lorren

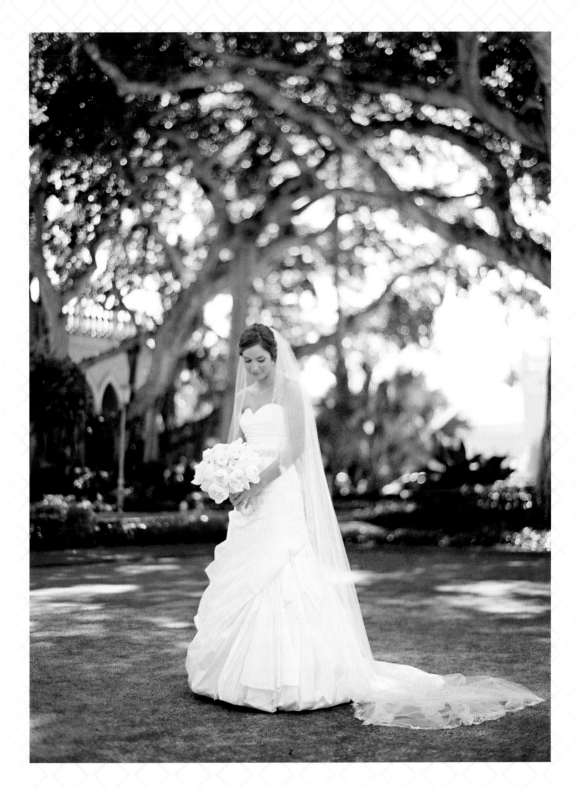

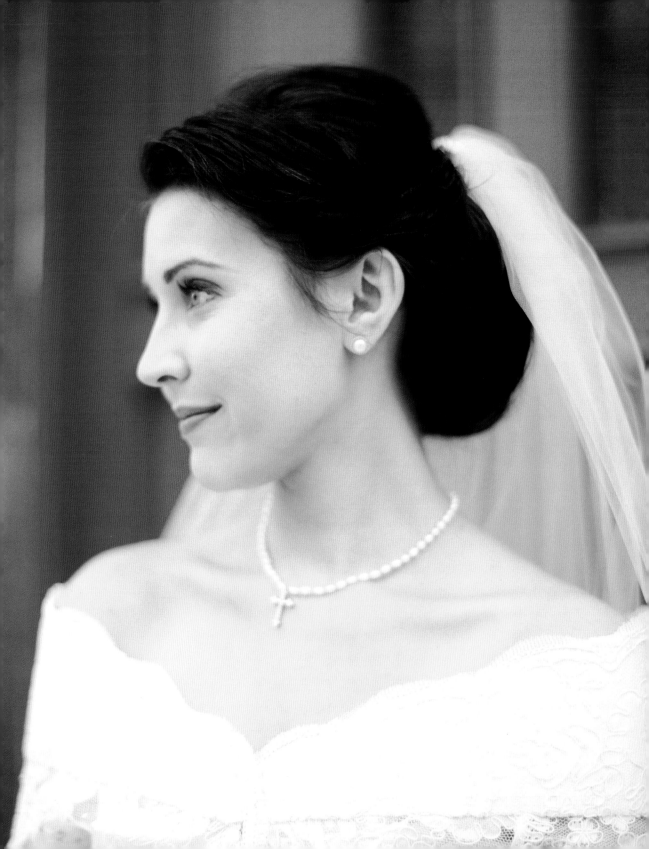

pretty profile

A classic profile can be perfect for showcasing a bride's features and veil, here given an updated spin with a colorful contrasting background. Find a colorful wall or door, and position your bride in front of it. While standing at eye level with the bride, have her turn to look to the side with a slight smile on her face (this will help prevent harsh facial lines). For a second capture, take a complementary photograph of the groom in front of the same background and pair the images together as a diptych.

TIP Look for colors, elements, and backgrounds that correlate with the style of the wedding day. This attention to detail will appeal to clients and create a cohesive look for their entire wedding photo collection.

A sidewalk in front of the shaded side of a building reflects soft mid-afternoon light back toward the bride.
80mm Zeiss lens, Fuji Pro 400H film, f/2 for 1/250 sec., ISO 400
Photo by Jessica Lorren

longing

Timeless and elegant, this pose embraces mood for a spectacular, heightened result. Photographing from a slightly higher angle to flatter the subject, have the bride stand facing a window or overlooking a balcony with her back toward the camera. Ask her to shift her weight to one leg, forming the lovely S-curve traditional in painting and portraiture of women, and lift her hair behind her head, being careful to keep her shoulders relaxed and not hunched up. The result, when combined with her long dress and high heels, is sexy and elongating. For another gorgeous capture, move in closer and ask the bride to look in a different direction as she lets her hair fall.

TIP Backlighting not only creates beautiful definition in the bride's form but also helps de-emphasize features that might not be as desirable in images, such as wrinkles in skin, which can be unflattering.

In this beautifully lit, but still dark, ballroom, the photographer combined a high ISO with a slow shutter speed and wide aperture to bring in enough light.
80mm Zeiss lens, Ilford 3200 black-and-white film, f/2 for 1/16 sec., ISO 1600
Photo by KT Merry

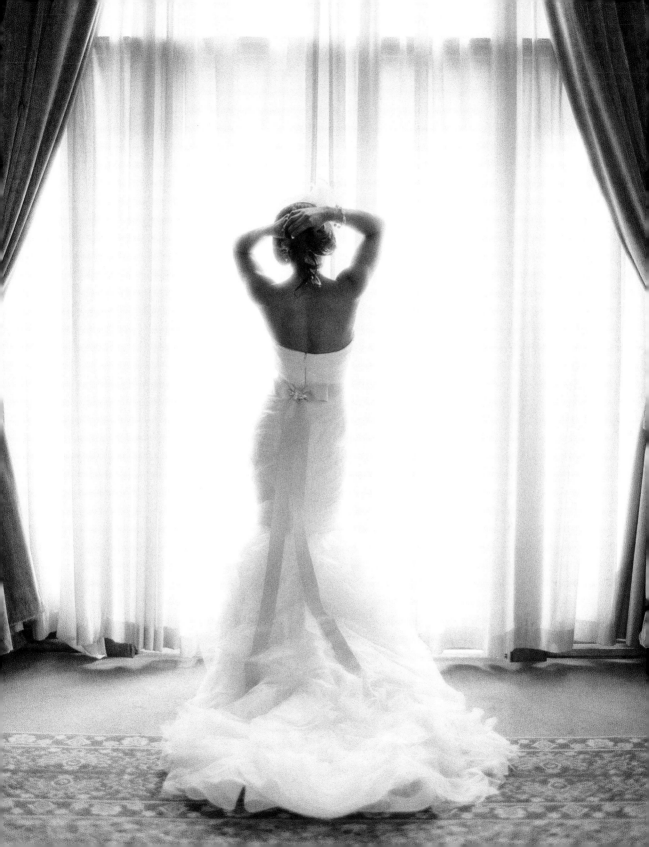

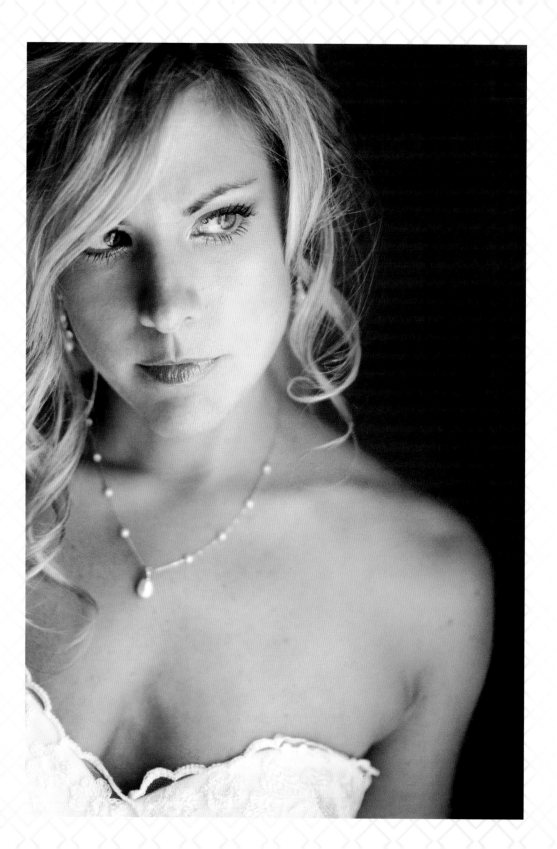

change of face

For a portrait that puts a fresh face on the standard with plenty of attitude, ask the bride to lean against the window frame and look out of the window. First, shoot a tight photograph of just her face and the top of her dress. Next, capture a pulled-back version that includes her pretty smile and bouquet. Finally, photograph a detail frame of just her flowers.

TIP Use time immediately before the ceremony (when the bride is supposed to be hidden away from guests) for a few quick window portraits that capture her anticipation and excitement.

Indirect window light casts a soft, flattering glow on this bride as she leans on the wall next to the window.
50mm F1.2 lens, f/1.2 for 1/800 sec., ISO 2500
Photo by bobbi+mike

flower power

For this quintessential bouquet portrait, ask the bride to stand with her back to a window while holding her bouquet. Use a shallow depth of field for a dreamy quality, and shoot from the level of the bouquet. The choices the bride makes for her flowers and accessories are important, since many have sentimental meaning. Look for subtle details, like this vintage handkerchief hanging from the bouquet, and focus in with a tighter crop. For a sweet-smelling second capture, have her hold the bouquet closer to her heart.

TIP Ask the bride to have her invitation, all rings, dress, shoes, jewelry, and bouquet available in her bridal suite for you to photograph when you arrive. This will allow you to spend more time taking pictures of the details and less time scrambling to assemble them.

A window sheer in the hotel room creates soft backlight behind the bride that wraps around her and casts perfect light on her bouquet. Here, an assistant holds a white reflector to fill in shadows on the flowers. 80mm Zeiss lens, Fuji Pro 400H film, f/2 for 1/60 sec., ISO 200
Photo by KT Merry

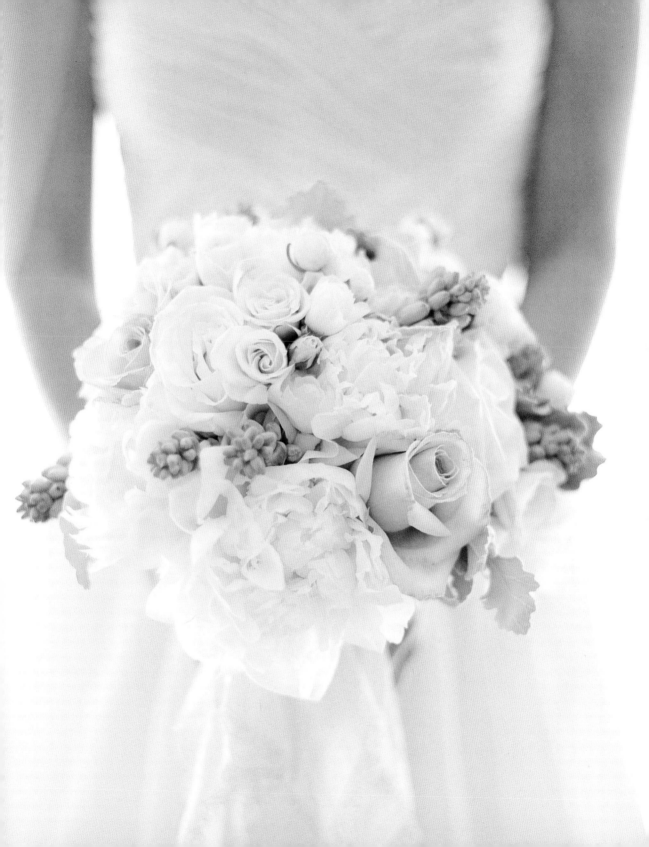

looking up

A low perspective and careful composition evokes the feeling of being immersed in an environment while focusing the eye on the bride in a subtle way and keeping the background behind her clean. Place the bride on a swell, dune, or mound, while placing yourself low in the landscape. Position the bride so that she faces you, and ask her to look out into the distance. After your wide shot, zoom in closer and grab a tighter frame; then bring in the groom and have him give her a hug from behind. Shooting through blowing grass in a gust of wind (when available) creates a romantic sense of movement.

TIP Before you press the shutter, ensure that everything in the frame contributes to the desired feeling of the portrait. Here, framing the bride in the right third lends a dramatic quality without cropping, and the blurred grass in the foreground adds to the feeling of softness.

Soft, late-afternoon light heavily diffused by ample cloud cover evenly highlights this bride.
80mm Zeiss lens, Kodak Portra 160 film, f/2.8 for 1/60 sec., ISO 160
Photo by Kat Braman

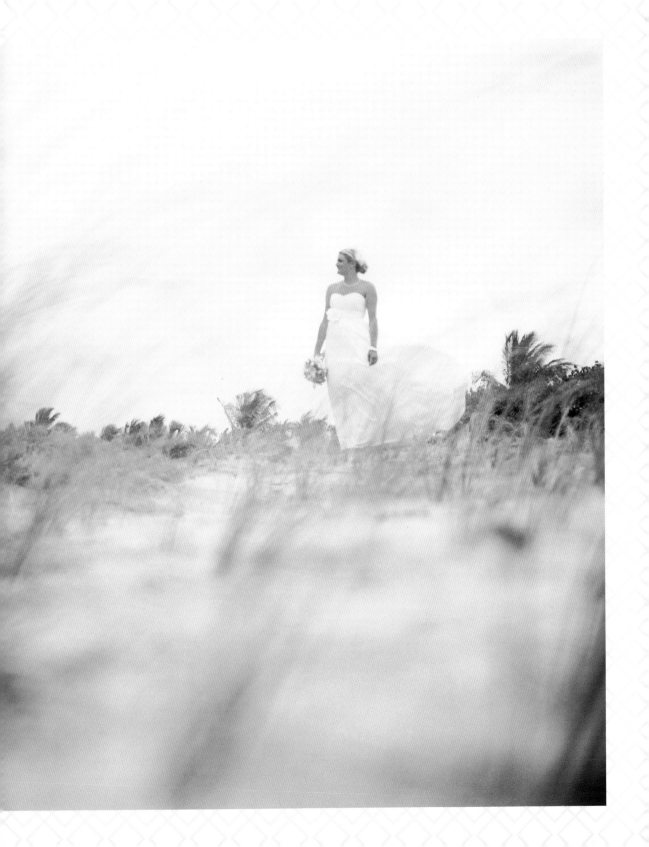

about face

For a turn of events, this unique portrait singles out the bride with just the gents in the wedding party for a more dramatic contrast than a standard "face front" pose. Turn the men around and have the bride stand in the center, leaning on one of the guys while facing the camera. Keep a close crop and the men will block out any distracting background. For a second capture, have the bride glance up toward her groom, or snap a couple shots of her looking from side to side.

TIP Use the height of the groom or groomsmen to your advantage to frame the portrait and create a focal point on the bride. Here, staggering their heights creates interest and visual layers while also hiding potential distractions, such as cars or tourists.

This shaded sidewalk helped bounce light back up to the bride, creating a more flattering neckline. 35mm F1.2 lens, f/3.5 for 1/200 sec., ISO 320 Photo by Heidi Geldhauser with Our Labor of Love Photography

perfect pairings

Successfully pairing the little elements a bride curates for her day shows that you paid attention to the details that are important to her. For this graphic shot that pairs her jewelry and veil, position her next to a window and ask her to hold her veil gently with her left hand, making sure her engagement ring is visible. Ask her to look out the window, which allows you to include her earrings, as well, often special family heirlooms. For a second capture, pull back to include the rest of her face. Consider pairing other details, like her bouquet and hemline or her unique shoes and veil.

TIP Look for walls and furnishings in colors that complement the bride's skin tone, and use them as backgrounds. Here, a peach wall brings out the rosy tones in the bride's skin.

This bride was photographed outdoors on a bright afternoon against a wall in open shade.
80mm Zeiss lens, Fuji Pro 400H film, f/2 for 1/500 sec., ISO 200
Photo by KT Merry

dash of panache

This stunning, editorial capture is another way to showcase your bride's dress and accessory details. Position the bride facing a window with her back to you, and ask her to bring one hand to her head, drawing the viewer's eye up toward her hairpiece. Then have her place the other hand in front of her shoulder. Shoot wide so that backlighting frames her figure, shimmering through the crook of her arm. This image also works with no hairpiece and with both hands in the hair. For a spectacular second photograph, have her place her hands on her waist to emphasize a detail on her waist, such as the bow here.

TIP Try to photograph moments in between your portraits. It's one thing to photograph the bride's mother posing, casting an adoring glance at her daughter in her wedding gown; it's another to grab an unscripted image of Mom's hands clasped together in honest emotion when she sees her daughter as a bride for the first time.

Though shot near a window, low lighting in this portrait required a high ISO film and a soft, white reflector held by an assistant to fill in the subject. 80mm Zeiss lens, Ilford 3200 black-and-white film, f/2 for 1/60 sec., ISO 1600 **Photo by KT Merry**

brides and grooms

Capturing brides and grooms blissfully in love is the heart of wedding photography. It takes time and practice to create portraits that are natural and represent the uniqueness of the couple.

To encourage the sweet, romantic bond between the bride and groom on their wedding day, keep dialogue going, whether you are offering feedback, encouragement, or prompts for posing. Step in occasionally to demonstrate exactly how you would like a bride or groom to pose. Perfect portraits aren't always about precise positioning as much as they are about the connections you capture, such as when a kiss turns into laughter or when a couple's hands, clasped together, lead to a beautiful crop of their rings.

Nervous brides and grooms need to hear that they are doing well, so lavish them with genuine praise. Smile to show that you're enjoying their day with them. Ask for their ideas beforehand, and incorporate them whenever possible.

Model behavior you would like to see in your clients by acting in a calm, positive manner, and respect the many interruptions that will, no doubt, punctuate your found moments. Take polite advantage of opportunities as they arise, and make sure the couple is allowed to enjoy their day.

Remember that each wedding is a blank slate, a new story to tell. With a little encouragement from you, the resulting portraits will forever mirror fond memories of togetherness.

Photo by Elizabeth Messina Photography

embrace from above

White wedding car or limousine, white wedding dress, black tuxedo, gray sidewalks and street—these are visual ingredients in almost every urban wedding, yet they can be combined to create this surprisingly modern, almost monochromatic composition. Find a moment when the wedding car is parked nearby, and position the happy couple a short distance away, aligned with the front of the car. Quickly access your predetermined vantage point from above; then ask the bride and groom to embrace. For another lovely frame, create an image of them getting into the car, as if they are leaving.

TIP Sometimes simple is best. As an exercise in creativity, try to deconstruct compositions until you have only the most important elements left. In this case, focusing on only two key elements (the car and the couple) creates a unique, modern, and uncluttered photograph.

Natural light diffused by a cloudy sky casts a lovely glow over this couple.
50mm F1.2 lens, f/3.2 for 1/500 sec., ISO 400
Photo by Anna Kuperberg

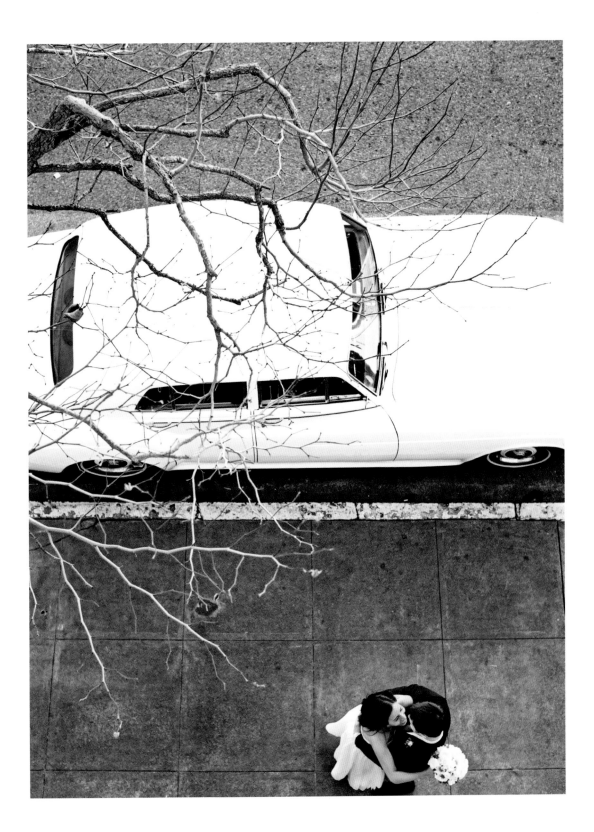

demure & dreamy

The keys to this sensual, soft image are the pose, the creative framing, and the shallow depth of field. Seat the couple on a bench, positioning the bride first and asking her to bring her chin out slightly to the side while looking down toward her toes. Then have the groom slide in behind her and kiss her shoulder. You'll want to shoot from an angle just high enough to showcase the bride's headpiece. Make sure the background is clear of clutter, and use a shallow depth of field to further focus attention on the couple. You can also step back and shoot from a lower perspective to show more of the groom and then snap a full-length portrait for variety.

TIP Play with cropping, and look for interesting background elements that add to your composition.

On a cloudy day, light-colored buildings, concrete, and stairs bounce diffused light back up to illuminate this couple with a subtle, creamy glow.
80mm Zeiss lens, Fuji Pro 400H film, f/2 for 1/125 sec., ISO 200
Photo by Tanja Lippert

into the woods

To create a magical moment that showcases timeless romance, have the groom lean against a tree with his legs set wide to support both himself and his bride. Instruct the bride to stand about a foot away from the groom's feet and lean into him with her hips. Because her chest is falling away from him, their chins can stretch out toward each other for a flattering profile and a little visual drama. Continuing to use this same tree, ask the bride to whisper in the groom's ear while standing in the streaming light for a series of photographs that create a dreamy, sensual story.

TIP A bridesmaid or an assistant can assist with your couple's portraits by arranging the bride's dress for each image and carrying the train as you change locations.

When shooting in the woods, locate pockets of light streaming through the trees for an almost dream-like effect. 80mm Zeiss lens, Fuji 800z film, f/2 for 1/90 sec., ISO 400
Photo by Tanja Lippert

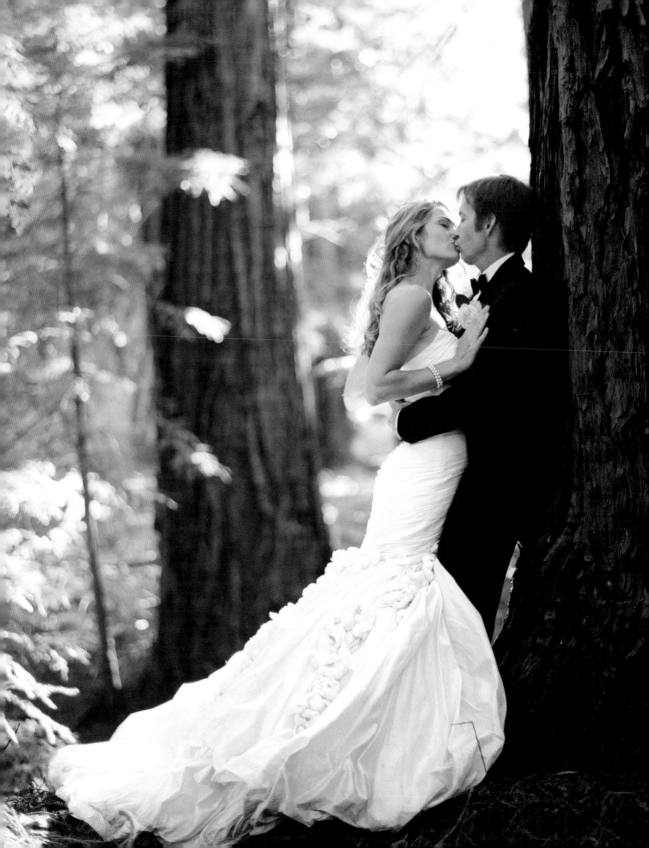

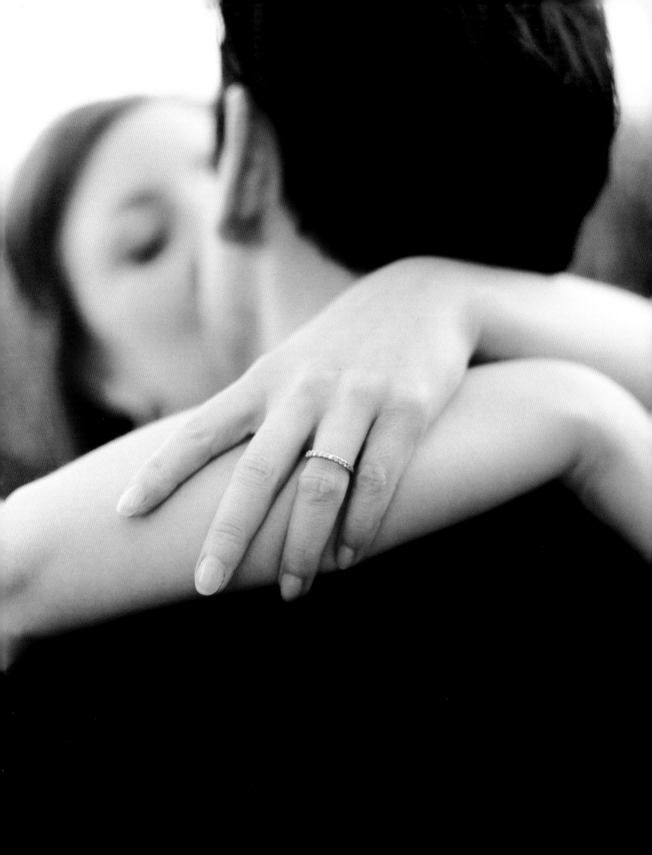

the ring's the thing

A touching moment between a bride and groom, soft colors, and a shallow depth of field combine for this strong, graphic ring capture. Have the bride place her arms lightly around her groom's neck, and move behind the groom for a shot of her fingers and ring, your shallow depth of field blurring their kiss in the background. From there, move to the side and snap a profile shot of them kissing; then grab one of them looking at the other; and finally, pose them cheek to cheek, looking at the camera. You can capture all of these moments full-length and then crop them waist-up for more image options in a short amount of time.

TIP Consider planning two portrait sessions with the couple on the wedding day: a "first look" session about fifteen minutes before the ceremony and then a second mini session right before sunset, when the couple is more relaxed and used to being in front of the camera.

Taken at sunset on the rooftop of the hotel wedding venue, this image is filled with a soft, subtle glow.
80mm Zeiss lens, Fuji Pro 400H film, f/4 for 1/250 sec., ISO 200
Photo by Lisa Lefkowitz

taking a
back seat

For a portrait that shows off your couple's wedding car and venue, have the car parked out front and place the couple in the back seat, seating the bride closest to you so that she isn't obscured by the groom. If the car has a closed top, open the back window or door. Move far enough back to include the entire car as well as architectural details of the venue in your frame; then ask them to nuzzle, snuggle, and kiss as you snap the shutter. Capture a second image from behind the car (or through the car's back window) as the couple looks at each other and, finally, with one of them looking at the camera.

TIP A rented vehicle means borrowed time, so direct the driver to position the car in good light with whatever background you choose to make each shot count.

Fog provides delicate, diffused light in front of this architecturally distinctive venue.
80mm Zeiss lens, Fuji Pro 400H film, f/4 for 1/250 sec., ISO 200
Photo by Lisa Lefkowitz

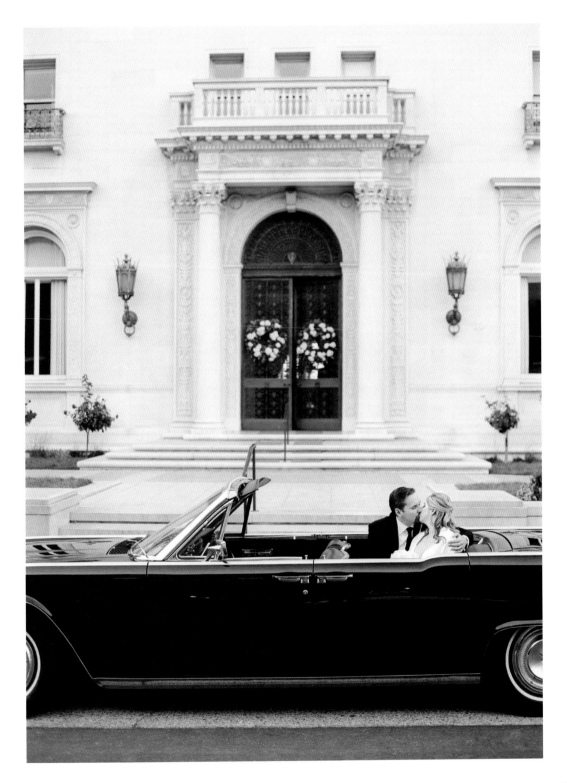

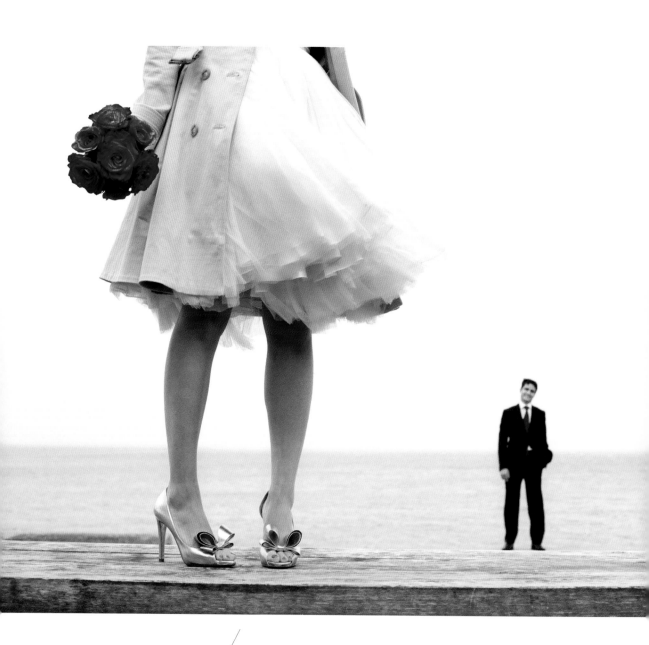

Cloudy, overcast skies create a moody portrait filled with character.
50mm F1.4 lens, f/6.3 for 1/500 sec., ISO 400
Photo by Anna Kuperberg

view to a thrill

Be innovative and look for fun angles, pops of color, and opportunities to play with scale and composition. To re-create this fun, slightly surreal pose, elevate the bride by having her stand on a bench or sturdy table with as clean a background as possible; then position her betrothed at a distance behind her. Shoot at the groom's eye level, but focus on the bride, blurring the groom in the background. Have the bride turn her feet inward for a bit of flirtatious fun and to call attention to her delectable shoes.

TIP The shoes a bride chooses are of huge importance. Always get a picture of the footwear, even if she is wearing a long gown, by having her raise her dress a little—or a lot—for a fun detail shot.

affection from afar

Architecture can be used to frame a bride and groom for a relaxed, contemplative moment that brings to mind a voyeuristic peek at the couple. Select a foreground element to use as a frame; then place the bride and groom on a bench or ledge, and ask the groom to clasp his hands casually as the bride folds over his arm to rest on his shoulder. For a second portrait, instruct the groom to look at the camera, zoom in slightly tighter, and capture several angles.

TIP For more gorgeous couple portraits without any stress, consider scheduling a day-after session. The couple will be extremely relaxed, and the bride will be less concerned with keeping her dress in pristine condition, enabling you to capture a variety of poses with ease.

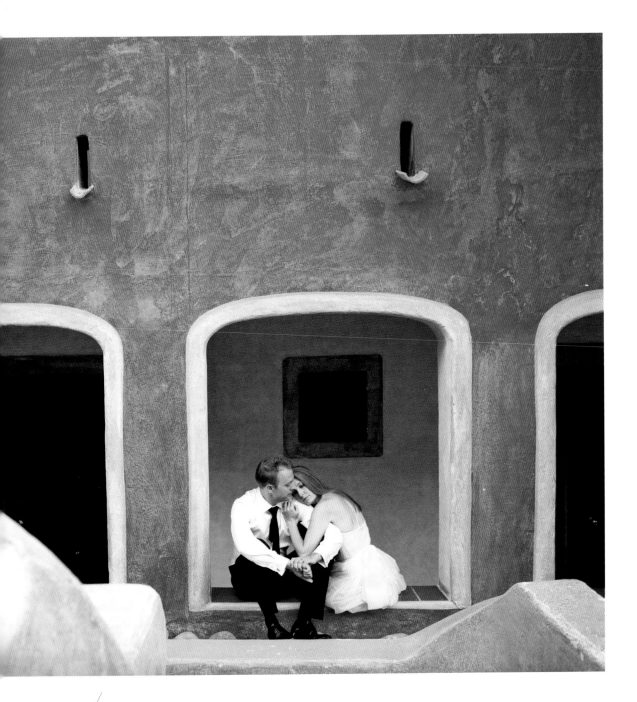

The open shade of an arched opening
shelters this couple from harsh sunlight.
35mm F1.4 lens, f/3.5 for 1/160 sec., ISO 400
Photo by Anna Kuperberg

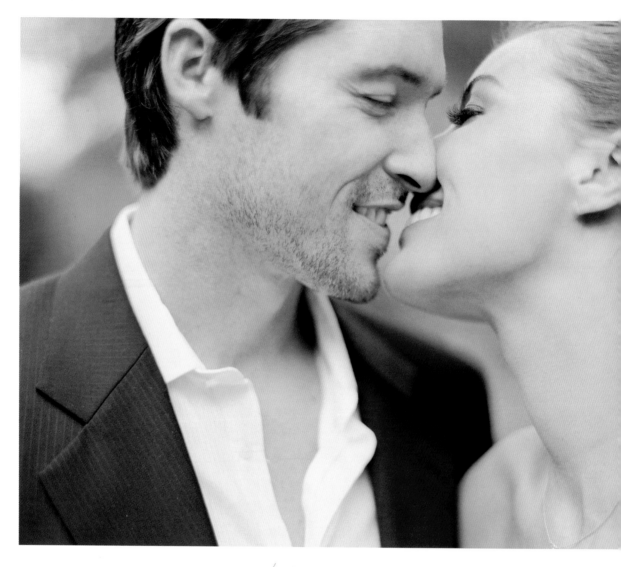

This couple was photographed in covered shade,
the sun peeking out from behind the groom.
80mm Zeiss lens, Ilford XP film, f/2 for 1/60 sec.,
ISO 400 (printed in sepia)
Photo by Elizabeth Messina Photography

kiss this

The iconic kiss photograph is important for every wedding. That said, there's something special about the moments leading up to the lip-lock with its gentle tension, longing, and anticipation of the moment. Ask your bride to kiss the side of her groom's mouth to elongate her neck beautifully as she reaches toward him. A tight crop and simple composition create a casual but very elegant photograph.

TIP Don't forget to snap the clean, classic portraits that relatives will love. Focusing on the sweet over the sensual will please family, since the only blush should be on the bride's cheek—not on her aunt's face. Once those crowd-pleasers are captured, have some more creative fun with angles, lighting, and cropping.

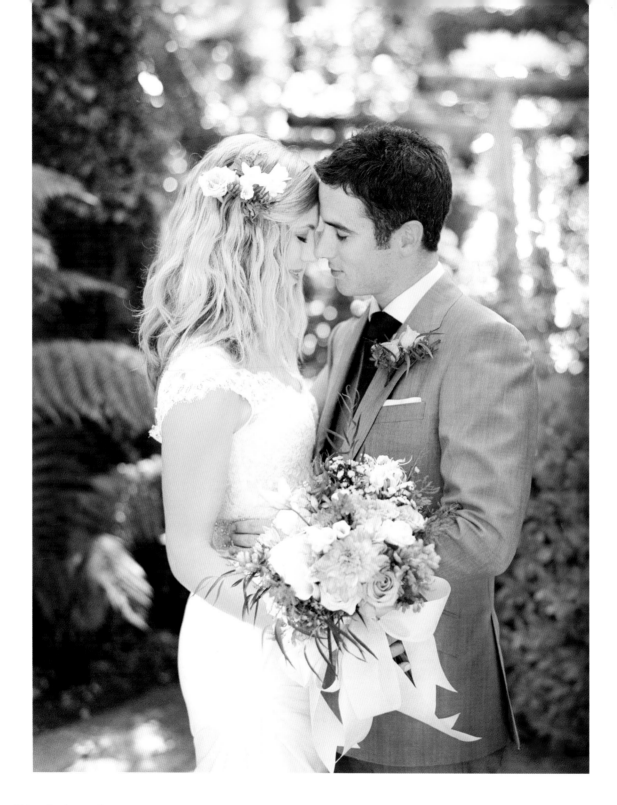

garden of needin'

Couples love romantic lifestyle pictures that place the emphasis on their attire and details, something this natural, emotional pose delivers in spades. Direct the couple to look into each other's eyes, arms entwined, and have them gently rest their foreheads together, noses touching. For follow-up shots, photograph them in a gentle kiss, and then pull back for a portrait of them gazing into each other's eyes, followed by a shot of them standing cheek to cheek while looking at the camera. Finally, without re-posing them, move in and out to snap waist-up and full-length images.

TIP A highlight of this pose is its focus on the bouquet, so be sure to pay attention to how it will appear in the photo. Having the bride angle it slightly toward the camera is best.

For tricky noon lighting, place your couple in a pocket of shade, as here, and use a shallow depth of field so that the surrounding bright areas pop without taking over.
80mm Zeiss lens, Fuji Pro 400H film, f/2.8 for 1/125 sec., ISO 200
Photo by Lisa Lefkowitz

sweet shoulder

Using the groom as a focal point of an image can lead to a charming capture. Place the bride in front of the groom with her back to the camera, and ask him to gently embrace her around the waist, being careful not to pull on her veil. Ask her to hold his shoulder and stand slightly off-center, so you can see a bit of his body, as she tilts toward him for a gentle, slow shoulder kiss. A beautiful first portrait for this series would be to frame just the bride looking over to the side, showing her elegant hairstyle, veil, and dress back.

TIP Always place clients several steps in front of the wall or background so that it blurs slightly out of focus.

Taken on a bright afternoon, this image of a couple's sweet, private moment is softly illuminated in the open shade of a courtyard.
80mm Zeiss lens, Fuji Pro 400H film, f/2 for 1/1000 sec., ISO 200
Photo by KT Merry

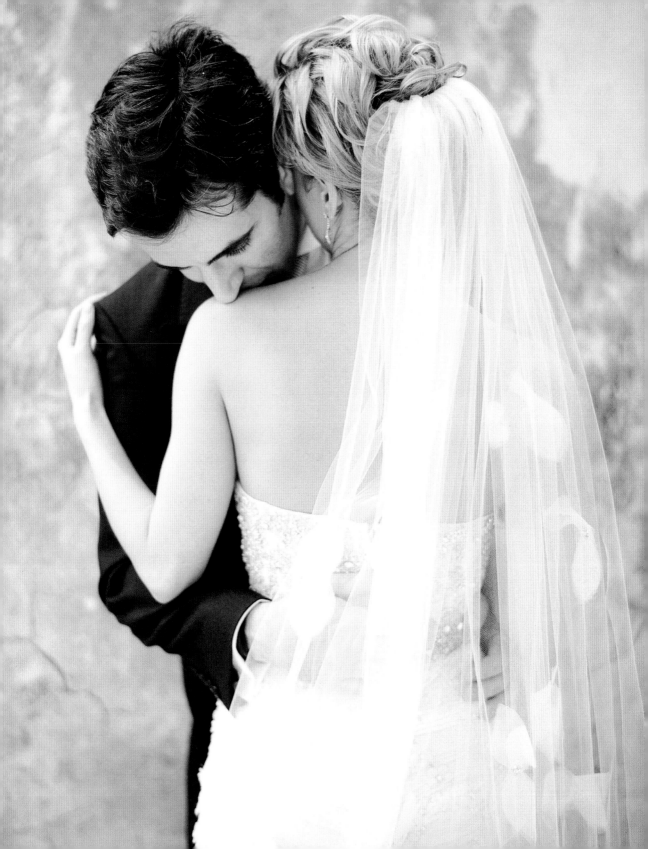

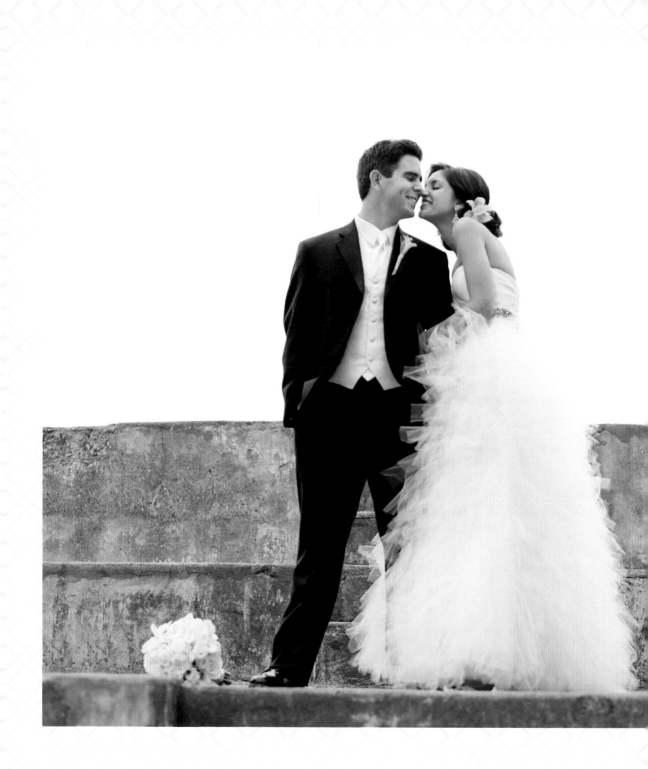

clever contrast

This sweet, flirtatious pose gets some interesting contrast when set against a gritty surface. Have the couple stand on a platform above you so that you can shoot at an upward angle. As the groom stands tall and strong with his hands in his pockets, instruct the bride to face him while twining her arms through his. Ask her to bring her hips toward him, connecting the two visually, and have her bring her shoulders into his as if she were cold. To get them to giggle, say something funny, or ask him to tell her a secret.

TIP Even if you tire of hearing yourself talk, constant direction and encouragement are often needed to keep couples performing and focused for the session.

The gray sky of an overcast day provides open shade filtering for this couple, while the concrete bounces subtle light back onto their faces.
80mm Zeiss lens, Fuji Pro 400H film, f/2.8 for 1/250 sec., ISO 200
Photo by Tanja Lippert

side by side

A from-above perspective draws the eye down to the couple seated side by side. Regardless of the environment—whether in a boat or seated on a park bench—place your couple close together, facing each other, and ask them to chat about something wedding-related (such as how they think their first dance will go). Look for how they interact, turn into each other, and engage hands. Take advantage of their playful expressions. For a second capture, have him lean his head on her shoulder if he is the romantic type.

TIP When posing your couple side by side, ask the groom to put his hand on the small of the bride's back rather than her waist, for a cleaner look that engages limbs without his fingers peeking around her side.

Soft, even, "golden hour" sun means less worry about shade or shadows.
80mm Zeiss lens, Fuji Pro 400H film, f/2 for 1/1000 sec., ISO 400
Photo by Jessica Lorren

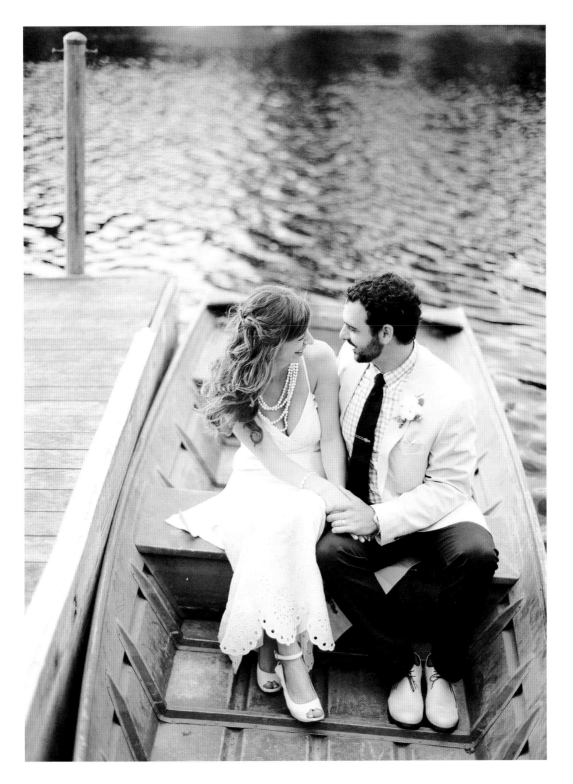

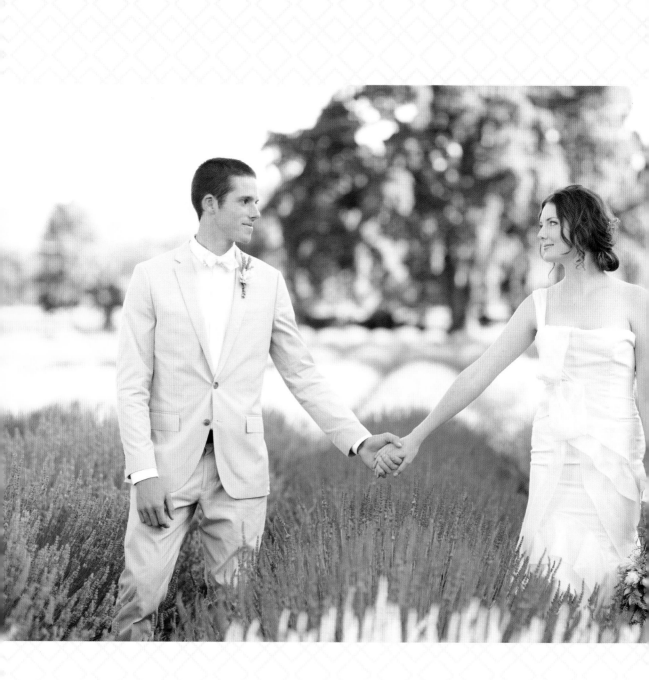

private party

Sometimes capturing an interesting portrait of a bride and groom at their wedding location requires embarking on a brief walk or golf cart ride away from the wedding festivities. Once you have scouted the perfect location, place the bride and groom at arms' length from each other so that when they clasp hands they form a letter M. Ask them to look at each other and share a soft smile, and direct the bride to drop her bouquet to her side for a relaxed look. Next, capture images with movement, whether they are swinging their arms or he sweeps her in close and dips her gently for a kiss.

TIP Try shooting with a prime lens; it forces your body to move for new, interesting compositions and challenges you to look at the whole frame, making calculated adjustments and decisions instead of quickly zooming in and out.

The open shade of a nearby building prevents this couple from squinting in the harsh, late-afternoon light.
80mm Zeiss lens, Fuji Pro 400H film, f/2 for 1/1000 sec., ISO 200
Photo by KT Merry

close encounter

A three-quarter pose of the bride's face is often more flattering than a classic profile. Position the bride in front of the groom, and have her wrap her right arm around to softly grasp his left hand. Ask the groom to kiss her temple or her ear from behind, which will often make her smile as she enjoys the moment. Have them engage their hands to keep them connected, and call attention to her rings. For another capture, ask them to kiss and then turn to hold each other, framing portraits in full as well as cropped from the waist up.

TIP Zoom in and crop close to capture details like the bride's ring and the groom's boutonniere with sharp detail and clarity. If in doubt over which hand to photograph, make sure it's the one with the ring.

Sunset backlighting creates a romantic ambience and the mildest suggestion of solar flare.
50mm F1.2 lens, f/2 for 1/2000 sec., ISO 1000
Photo by Milou + Olin Photography

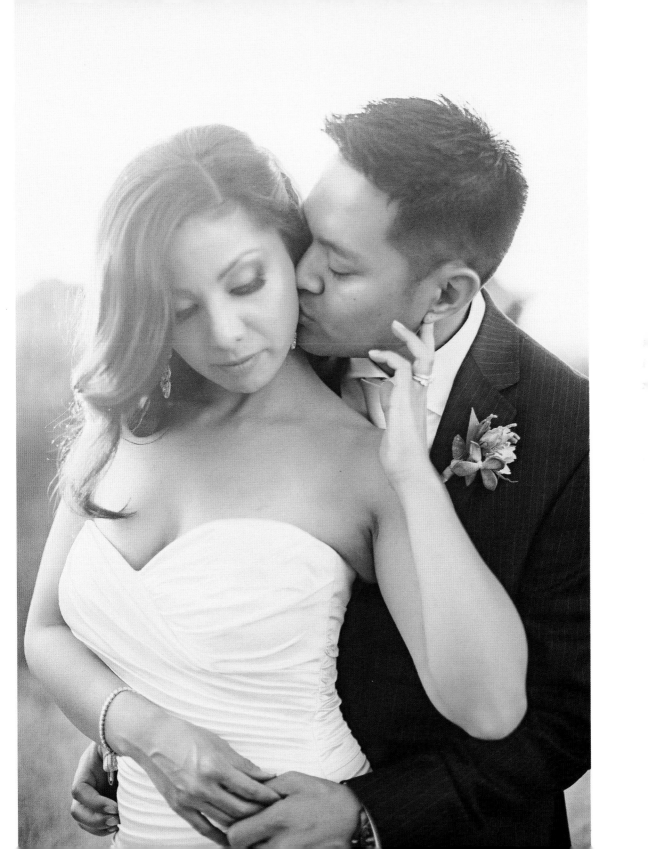

take a lap

In this classic seated pose with a twist, the bride perches on the groom's lap, instead of next to him, to bring them closer together. Have the groom face to his right, and place the bride comfortably on his legs facing the camera. Arrange their faces cheek to cheek, and make sure their hands are connected. For a sweet second shot, capture him kissing her cheek or telling her a secret for a genuine facial expression.

TIP Consider an interesting light-colored wall or sky behind your couple to create depth and physical separation. Then make sure that a little space shows between her waist and his torso to slenderize her waist.

Light filters from behind the photographer into this sheltered area, necessitating a slight bump in ISO.
80mm Zeiss lens, Fuji 800 NPZ film, f/2 for 1/160 sec., ISO 800
Photo by Elizabeth Messina Photography

happily
ever after

An elegant fairy-tale frame, this capture is sublime for a wedding album cover or large display canvas. A nearby tree frames to the right, while a shallow depth of focus blurs the background, adding to the dreamy scene. Be sure the couple is up for a shot like this first, since it is definitely more adventurous. Ask the groom to sweep his bride up into his arms as he moves toward the camera. Modify this pose by having her seated on his lap on a bench or natural perch. For a lovely second portrait, zoom in tight for a horizontal frame.

TIP When you don't have a second camera body or can't afford extra lenses, rent them. It's inexpensive to do so and allows you to grab more varied portraits.

Afternoon light touches the treetops but not the couple, who are ensconced in bliss and open shade.
80mm Zeiss lens, Fuji 400 NPH 400 film, f/2 for 1/250 sec., ISO 400
Photo by Elizabeth Messina Photography

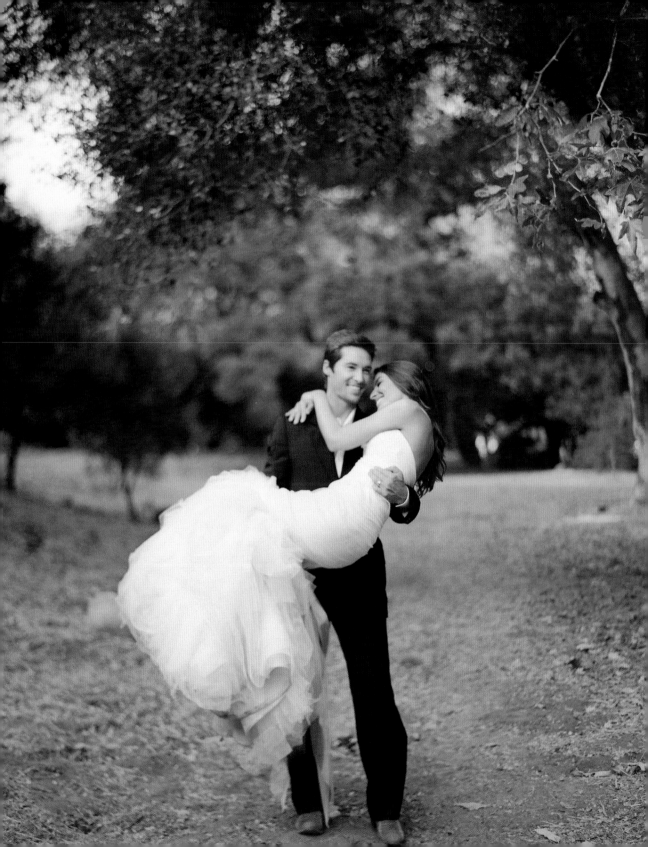

third's a charm

The Rule of Thirds is a classic composition technique of dividing an image into nine equal parts, like a tic-tac-toe board, and placing your subject on one of the points where the lines cross. Here, the Rule of Thirds allows you to highlight a romantic moment between a bride and groom as well as beautiful scenery from their wedding venue. Ask the groom to wrap his arm around the bride's waist, drawing her in, and then kiss her hand. For follow-up images, snap the shutter as they smooch and as he sneaks a forehead kiss.

TIP Show up early to photograph the venue's landscape for the wedding album. Not only will these images create appreciated variety in the photographs but venue owners who like what they see might even offer referrals.

At this winery venue without any shade, evening backlight provides more forgiving light. 24–70mm F2.8 lens, f/2.8 for 1/1600 sec., ISO 200
Photo by Milou + Olin Photography

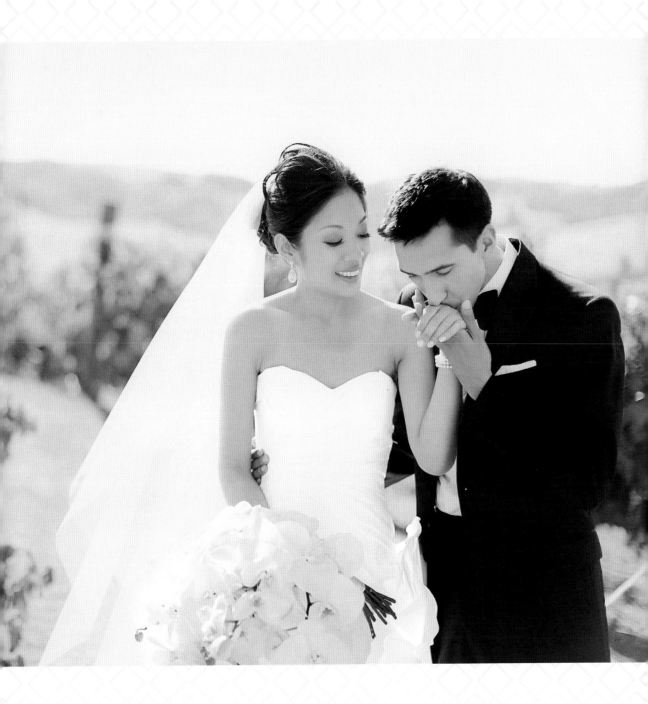

clean & classic

This clean, classic portrait is one a couple can proudly present to their families for display—both of their faces are seen clearly, it is not too intimate or sensual, and it shows off their wedding attire. While photographing the couple, let them know that you are about to shoot a proper portrait for their family. Look for flattering, even light, and use a shallow depth of field for a softened background. Encourage cuddling and snuggling, and have them intertwine hands. Direct the groom to place his other hand on her arm to show off his wedding band. Tilting the bride's head back slightly connects their faces and eyes on the same plane. A slight camera tilt adds interest without being overly distracting.

TIP Bring a white sheet for portraits in wet areas to protect the bride's shoes and dress. Tuck the sheet underneath her gown so that it won't show up in images.

In this afternoon session, open shade is provided courtesy of the nearby trees.
80mm Zeiss lens, Fuji NPH 400 film, f/5.6 for 1/60 sec., ISO 800
Photo by Elizabeth Messina Photography

love
from above

For a tender moment of a young couple, giggly in love, capture them from a slightly higher angle. Choose a plain background or wall, and have the couple lean against a low ledge or table. Ask the groom to almost envelop his bride in his arms and body. Arms and hands should be connected, with faces close together to portray an intimate portrait. For another beautiful image, shoot a picture from eye level while sitting; then zoom in for a tighter frame.

TIP Not every photo location has to be stunning and over-the-top. Simple backgrounds and quality light place all of the attention on your subjects.

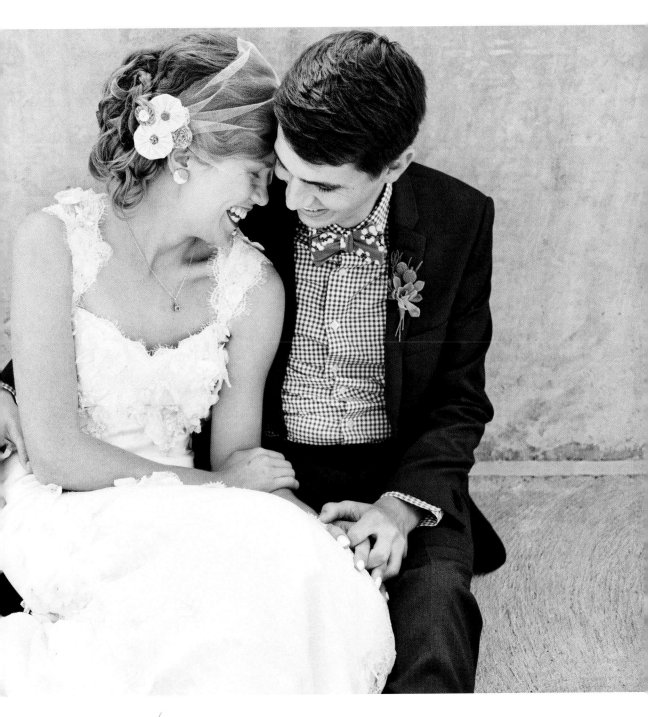

This cuddly moment was captured,
surprisingly, in a parking garage in open shade.
35mm F1.4 lens, f/3.5 for 1/1600 sec., ISO 250
Photo by bobbi+mike

i melt

Brimming with romance, this pose captures the intimacy and softness between two subjects. Ask the couple to melt into each other, first by having the bride soften her hip slightly, putting weight on one leg, and then letting her bouquet drop from a relaxed arm. Place the groom facing his bride, with feet shoulder-width apart and with his forehead slightly behind hers as they connect facially (to keep the focus on the bride). His hand on her waist is very masculine and accentuates her form in a flattering way. Encourage them to take a deep breath and be quiet with each other. Once framed, try backing up for a horizontal frame, or move in to capture details of her hemline, bouquet, or jewelry.

TIP Vary the way you talk and gesture to convey the emotion you hope to receive from your subjects. For example, if you want a high-energy portrait, speak and move more enthusiastically. For a softer, more relaxed portrait, speak calmly and softly.

The weeping willow tree enhances the softly backlit location, while an overcast, rainy sky casts diffused light over the scene. 80mm Zeiss lens, Fuji Pro 400H film, f/2 for 1/250 sec., ISO 200
Photo by KT Merry

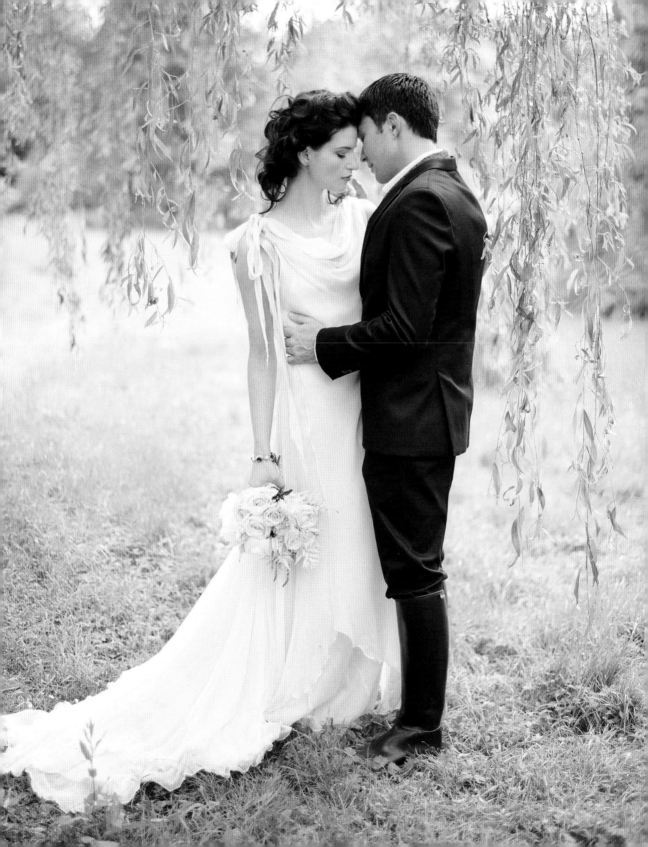

eye love you

This pose showcases a radiant bride's beautiful eyes.
Position the groom at a profile to the camera, and
ask the bride to give him a hug from behind. Move
the bride forward (closer to the camera) so that her
face is not blocked by his back, and ask her to look
right into the camera. For a second shot, step back and
take a full-body portrait. Then have her drop her arms
down and hold hands with him. Finally, have him turn
around and give her a hug.

TIP Poses that feature the bride, such as this one, are
perfect for a nervous groom, since the camera is not
focused on him.

**Harsh, midday light is filtered by a refreshing glass breezeway,
where the floor reflects and bounces light back into the subjects' faces.**
80mm Zeiss lens, Kodak Portra 800 film, f/2.8 for 1/125 sec., ISO 800
Photo by Kat Braman

heavenly hemline

This quirky, flirty image gives the bride a chance to show off her dress's hemline, her shoes, even her legs, if she prefers. As the bride is seated, place the groom to her side and have them hold hands. Look for ways to flatter the cut or the style of the bride's dress—in this case the soft, fluttery layers of chiffon. A dark background makes the image pop, further highlighting the dress. For a second portrait, try a picture of them standing side by side.

TIP Bring a bridal emergency kit to the wedding that includes sticky tape, pins, stain remover, deodorant, clear nail polish, and a pretty hanger (for the essential hanging-gown picture).

This sidelit location, with both shade and light, keeps the couple from washing out in the mid-afternoon sun.
24-70mm F2.8 lens, f/5.6 for 1/500 sec., ISO 400
Photo by Milou + Olin Photography

Rain or shine, umbrellas and parasols
help cast even, open-shade lighting.
85mm F1.4 lens, f/2.8 for 1/320 sec., ISO 360
Photo by Paul Johnson Photography

under cover

When confronted with rain on a wedding day, use it to your advantage. For this pose, stop the couple for a quick kiss under their umbrella, positioning yourself for an interesting vantage point (here, the planters on either side offer breathtaking symmetry). A wide-angle image of surrounding family and guests makes for a beautiful second portrait. This pose also works well in an archway, in a doorway, or on a path—anything that frames them. And even when there is nary a cloud in the sky, a parasol on a sunny day is another fantastic capture.

TIP Couples are typically nervous about inclement weather on their wedding day, so be sure to project confidence and create gorgeous photographs that will remind them of their special day.

sign of the times

"Just Married" signs are classic iconography from weddings. Have the driver position the car and ask the couple to sit in the back seat and snuggle up close. With a convertible, you can move around the couple while keeping them in the same pose. In a closed-top car, photograph through side or rear windows, through the doors, or with the couple posed near the rear bumper. Come in for a closer, cropped image. Finally, have the couple kiss and then look at the camera for a more traditional portrait. You can even ask the couple to simply stand and hold a fun sign like this. All of these will provide adorable portraits for home display and for featuring on custom thank-you cards.

TIP With your subject's permission, iconic images can also perform well as stock images to generate additional revenue. Classic captures like these have been published in various magazines as well as by card companies.

To manage the tricky, dappled lighting in this church parking lot, the car is positioned in the largest area of shade for uniform light. Some bright patches of sun illuminate the ground.
80mm Zeiss lens, Fuji Pro 400H film, f/4 for 1/125 sec., ISO 200
Photo by Lisa Lefkowitz

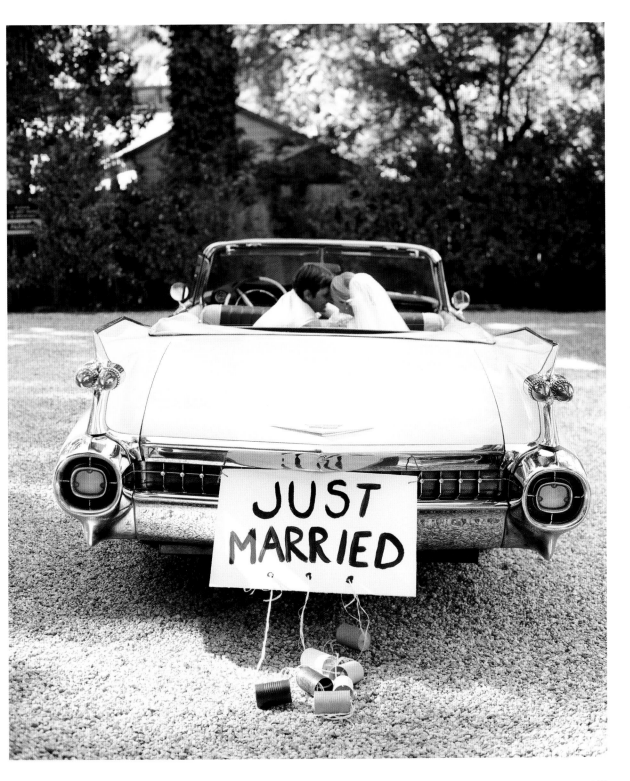

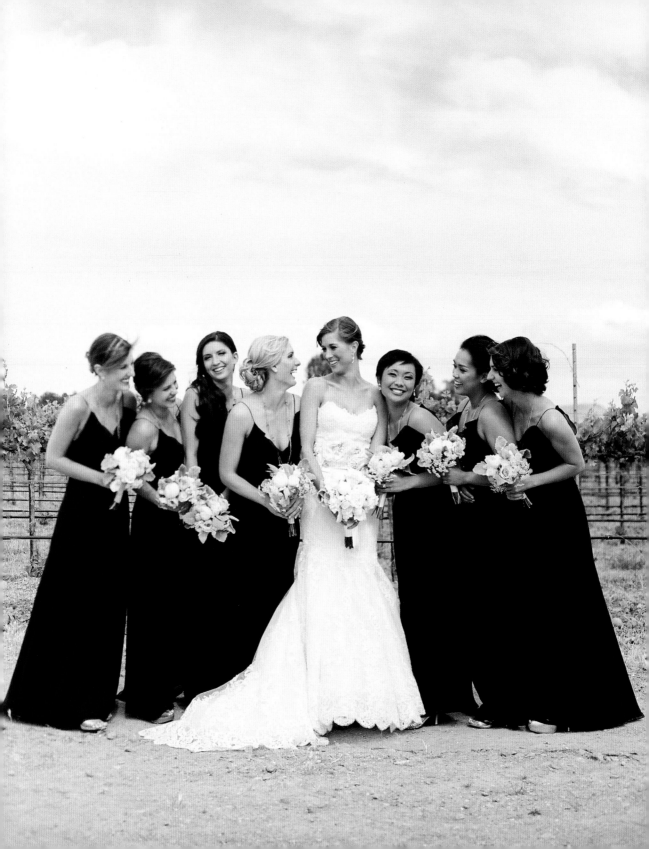

chapter four

wedding parties

Wedding party photographs require thought and planning. Groups can prove difficult to control and even more difficult to capture in a perfect portrait, especially in the swirl of wedding-day excitement.

Prepare by scouting the venue in advance and recording your ideas in a notebook or with your smartphone. During the session, use activities to spark interaction among group members, whether following groomsmen as they walk to a specific location or photographing the bride during a toast to her bridesmaids. Don't forget to capture brides and grooms with their siblings and show sensitivity to family dynamics.

Position groups for the most flattering natural light, and keep them from facing the sun to prevent squinting. Stagger party members for a more dynamic image, and consider asking some participants to look in different directions for a fresh approach.

Expect to grab images quickly. Bring a small folding stepladder for shooting large group photos from a slightly better vantage point. Once you position everyone in the wedding party, try changing your crop and angle instead of re-posing subjects for every portrait. Consider converting some images to black and white for a timeless look, especially when lighting isn't on your side.

Photographing wedding parties can be one of the more complex parts of the day, but it also provides an exciting challenge for bringing a diverse group together for images the bride and groom will embrace forever.

Photo by Tanja Lippert Photography

bridal sweet

For a quick, unique wedding party portrait, place the bride and groom as the foundation of the image and quickly build around them, layering in couples first and then individual members. Here, the wedding party is placed in groups of twos and threes, standing and sitting, with emphasis on the flower girls near the couple. Photographing the entire group in this way creates an editorial-style shot featuring dynamic posing and magazine styling. Step back to check the whole picture and make adjustments prior to snapping the shutter. After taking this wide image, move closer and capture verticals of the different sub-groupings.

TIP When photographing large groups, a telephoto lens creates a beautifully compressed look that flatters much more than a wide-angle lens. Just be sure to let the party know you are backing up to capture the image.

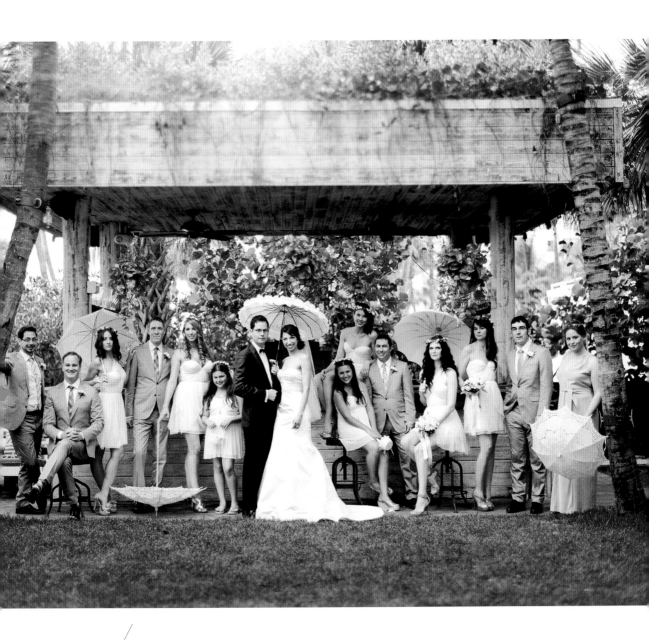

This enthralling scene was photographed just before sunset in open shade.

80mm lens, Fuji Pro 400H film, f/4 for 1/60 sec., ISO 200

Photo by KT Merry

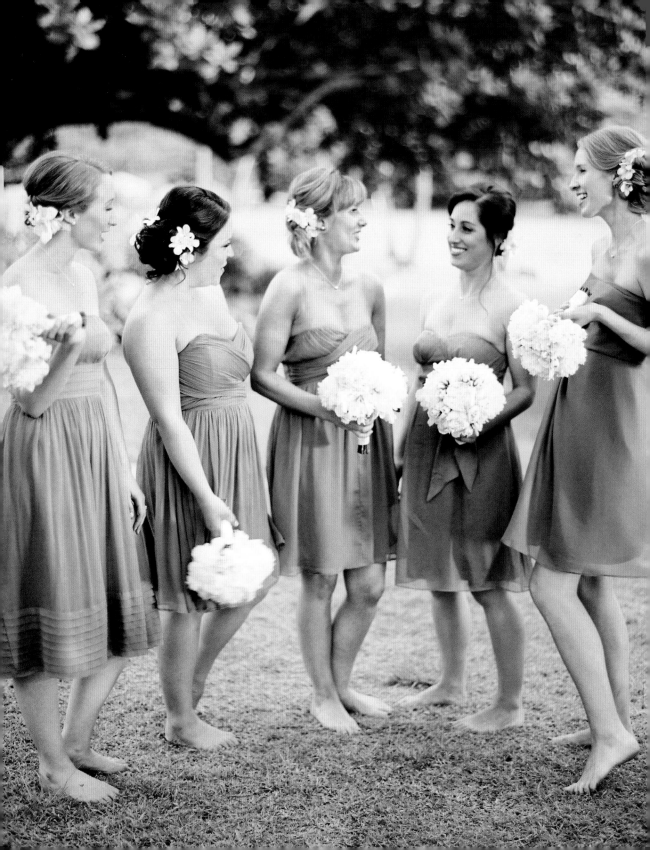

bring on the bridesmaids

Typically immortalized only with the bride or the groomsmen—but rarely alone—here's your opportunity to right that common wedding photography wrong. Choose a spot with beautiful light and a clean background; then position these beautiful belles close together in a V formation, with the tallest ladies framing the image. Allow casual conversation, and let them hold their bouquets in a natural way so that they stand comfortably and shift into different positions and gestures as you photograph candid moments. If a bridesmaid tells a joke and they all tilt their heads back in laughter, photograph that as well.

TIP Each time you photograph a new group, such as these bridesmaids, keep them involved and confident by explaining how the shoot will go before you begin (your style, how you direct, and what you need from them), so they feel comfortable turning to you for guidance.

A slightly overcast day spreads even light everywhere.
80mm Zeiss lens, Fuji 160S 220mm film,
f/2 for 1/125 sec., ISO 160
Photo by Jen Huang Photography

backstory

This mock bouquet throw against a bold, interesting background is the perfect way to make a playful, dynamic statement. Frame the bride standing far to the edge of the frame in an exaggerated preparation to throw. On the other side, pose the ladies very close together, reaching forward as they each hold their own bouquets slightly toward the camera. After photographing the posed bouquet throw, have the ladies and bride turn to face you for a second portrait. Finally, position the bride in the middle for an adorable group moment.

TIP Be inspired by your location, and let the space speak to you. Always be on the lookout for interesting backgrounds that you can use to produce memorable images.

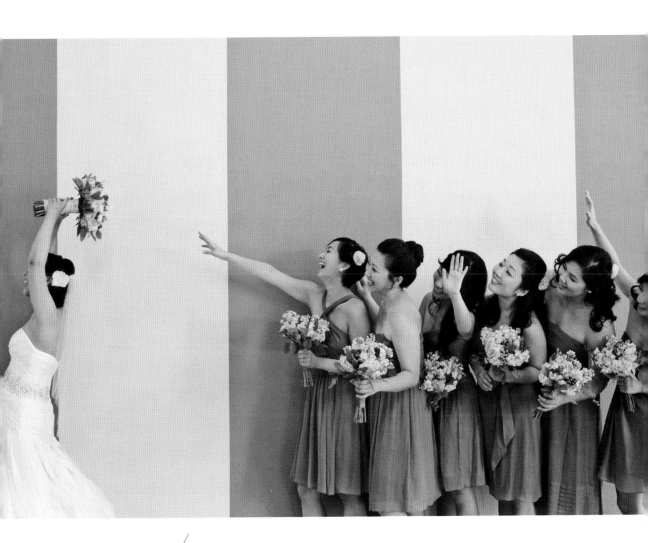

Strong afternoon light coming in through large windows and reflecting off a white ceiling filled this room with studio-quality illumination.
50mm F1.2 lens, f/5.6 for 1/250 sec., ISO 500
Photo by Heidi Geldhauser with Our Labor of Love Photography

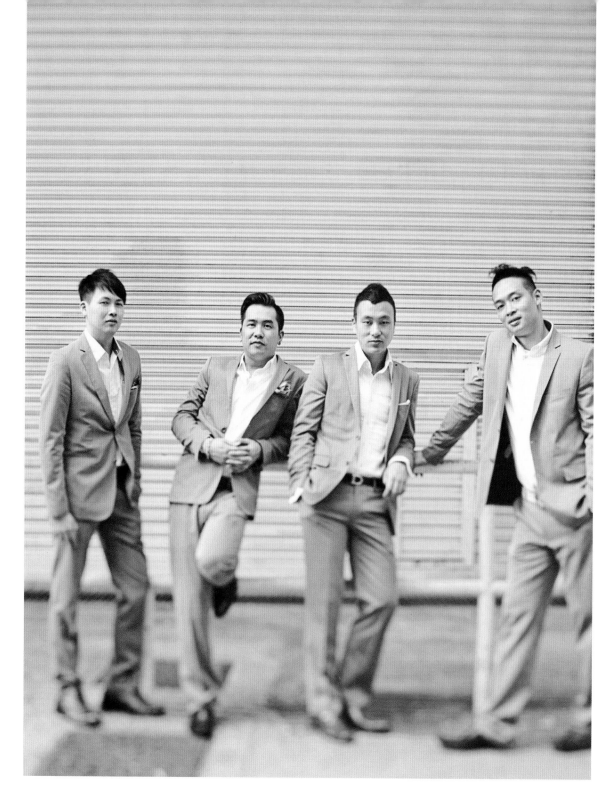

loose lineup

Posed casually and centered against a steel garage door, these groomsmen are so stylish they look like models. Simply ask the guys to talk while you set up your camera; then sneak a few pictures while they're not looking. When you're "ready," ask them to look at you very casually, staying relaxed. Then move back and ask them to walk toward you very slowly as a group, since movement helps accentuate the candid feel of a group photograph. The selective camera focus shown here can be achieved naturally through a tilt-shift lens or during postproduction.

TIP Think about the differences between feminine backgrounds, which tend to be floral and soft, and masculine backgrounds, which tend to be more industrial, textured, or linear. Strategically place men and women in these environments to add context to portraits.

As shown here, light-colored pavement bounces light upward, filling in shadows under chins and eyes for more flattering exposures.
45mm TS lens, f/3.5 for 1/125 sec., ISO 400
Photo by Heidi Geldhauser with Our Labor of Love Photography

creative casual

Separate the bride and groom from the wedding party in front of an interesting structure for a casual, quirky image. Place the group in two layers, or rows, with the bride and groom separate from the rest of the party and slightly forward. Follow up by photographing the people in both groups walking toward one another and meeting in the middle or continuing past one another to switch sides. Make sure everyone can see the camera so that all of their faces can be seen.

TIP As fun as strong sunlight can be, overcast skies grant the advantage of studio-like lighting, freeing you from worries about too much shadow or darkness.

On an overcast day, shadow-free lighting makes it possible to work within a large, open space.
35mm F1.2 lens, f/5.6 for 1/1000 sec., ISO 400
Photo by Heidi Geldhauser with Our Labor of Love Photography

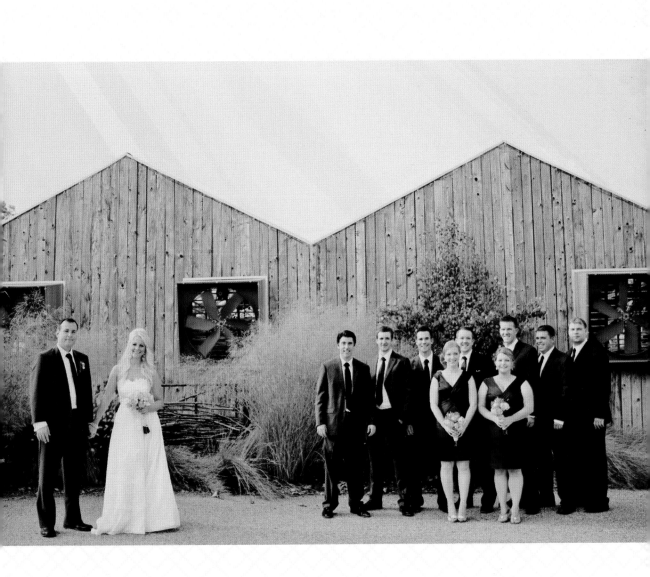

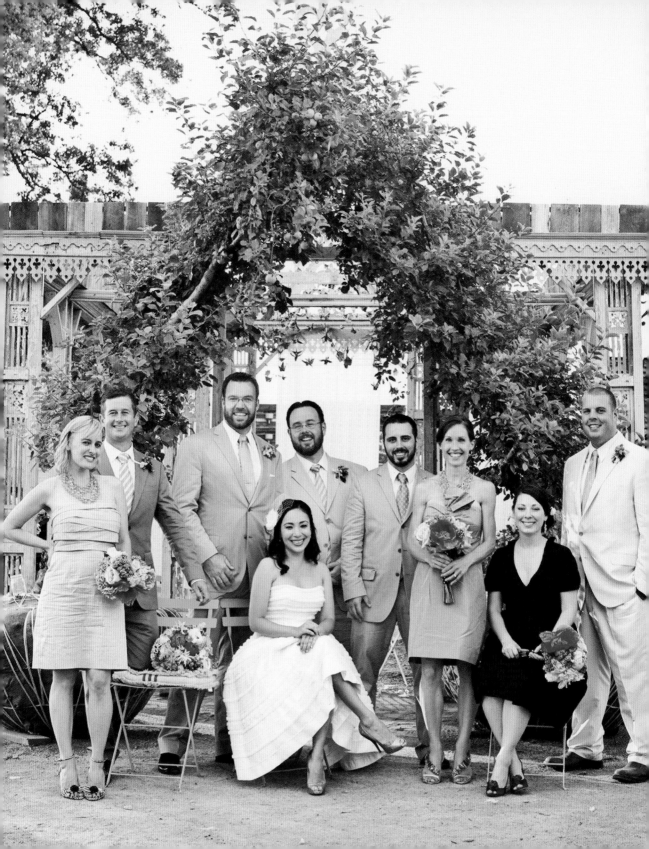

main squeeze

To fit a large group into a tight space, try layering people by having some stand and others sit, so the heights of the subjects flow up and down in a nice wave. Position the party carefully and thoughtfully so that no one is blocked. For second and third portraits, capture the girls only and then the guys. For other, more candid, photographs, ask the people in the group to talk to one another.

TIP Vertical group portraits are not common, so when photographing an average-size wedding party in a small space, step back and shoot vertically for instant depth and an image that will add variety to your portfolio.

The chairs in this image were positioned to allow the most light possible on the sitters, allowing the photographer to shoot at f/5.6, essential for capturing sharp facial details in a group.
50mm F1.2 lens, f/5.6 for 1/400 sec., ISO 800
Photo by Heidi Geldhauser with Our Labor of Love Photography

hand in hand

Large spaces, like fields, can lend themselves to powerful compositions, allowing a dramatically wide shot of the entire wedding party. Line everyone up, and position the bride and groom in the middle. Ask the best man to stand next to the bride and the maid of honor to stand next to the groom; then place the rest of the wedding party, alternating men and women. Move far enough back to include everyone in the frame, and direct the bride and groom to kiss. This grouping not only lends a variation in tone from dress suits to gowns but makes hugging and hand-holding easier.

TIP Whenever possible, ask if you can attend the wedding rehearsal, even just for a short time. This helps you cultivate relationships with key people, aids in better understanding personalities, and ensures more positive personal dynamics.

Later-afternoon sun from camera left creates long shadows across the landscape.
80mm Zeiss lens, Ilford XP film, f/5.6 for 1/60 sec., ISO 400
Photo by Elizabeth Messina Photography

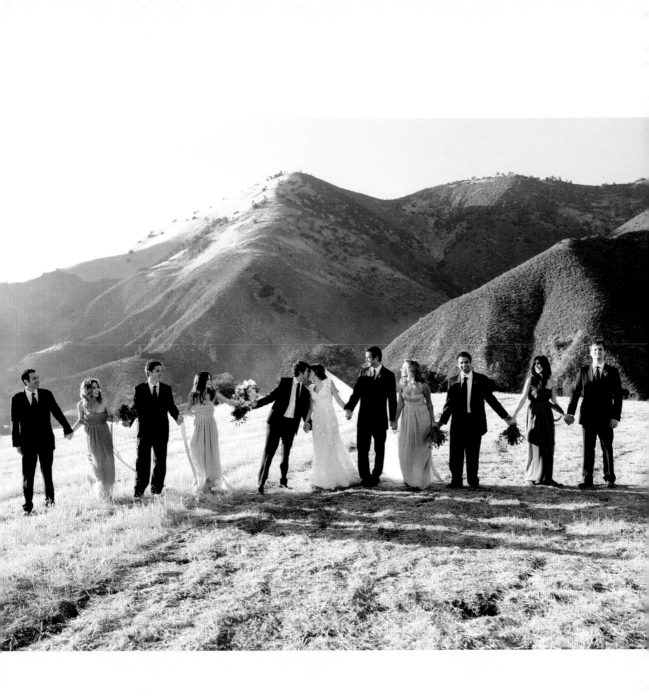

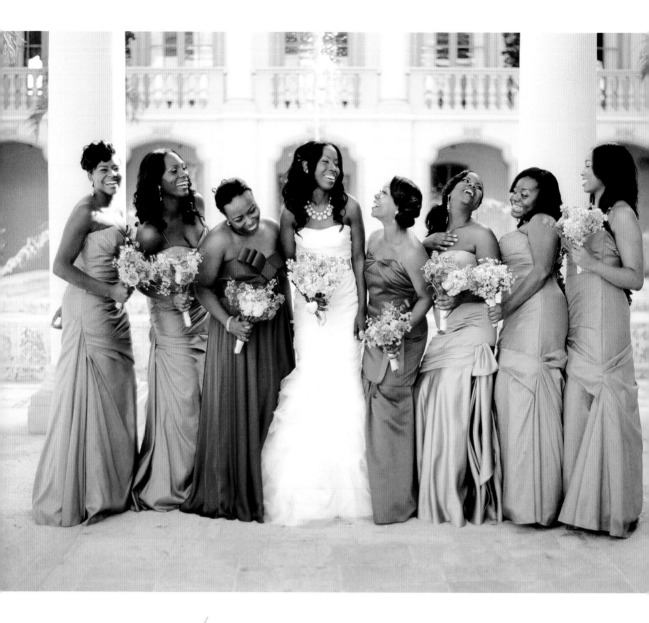

Here, nearby buildings grant open shade from the harsh afternoon sun,
while the stone underfoot acts as a natural reflector.

80mm Zeiss lens, Fuji Pro 400H film, f/2 for 1/4000 sec., ISO 200

Photo by KT Merry

group giggle

Capture a bridal group having fun and laughing together and it will quickly become a wedding favorite. Fan out the bridesmaids from the bride, starting with the shortest ladies on each side, then taller women, and last the tallest. After photographing everyone in a line looking at the camera, ask them to look at one another and giggle. (Often this request will leave them a bit shy, and laughter will erupt.) While the ladies are still in place, zoom in to frame a detailed crop of bouquets against their lovely gowns. Finally, zoom in closer for a tight shot of the bride and her maid of honor while they are laughing together.

TIP When photographing brides and bridesmaids, be sure to incorporate the bouquets. Aim the tops of the bouquets toward the camera to ensure a lush floral show.

hangin' with the guys

A luscious lifestyle collection of groomsmen portraits can reveal their personalities, friendships, and camaraderie. Choose a spot with beautiful light, such as the open shade of a large veranda, as here, and position a chair to showcase the groom with the groomsmen gathered behind him. After the standard "Everyone look over here and smile" photograph, ask them to share memories of the groom. As they interact and laugh, move and change your focus for a variety of pictures, including close-ups of various groomsmen's faces. Ask them to wait while you "test settings," and then capture their natural interactions before the posed shot.

TIP Compliments go a long way. Be sure to honestly let clients—and their parties—know how nice they look, and create a fun atmosphere in which they can freely joke around with one another and feel at ease.

This white front porch bounces bright, punchy light onto the groomsmen as they prepare for the ceremony.
50mm lens, Fuji Pro 400H film, f/4 for 1/125 sec., ISO 200
Photos by Tanja Lippert

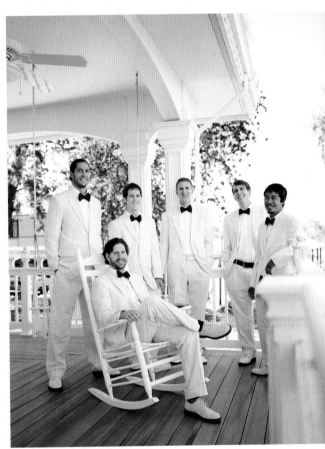

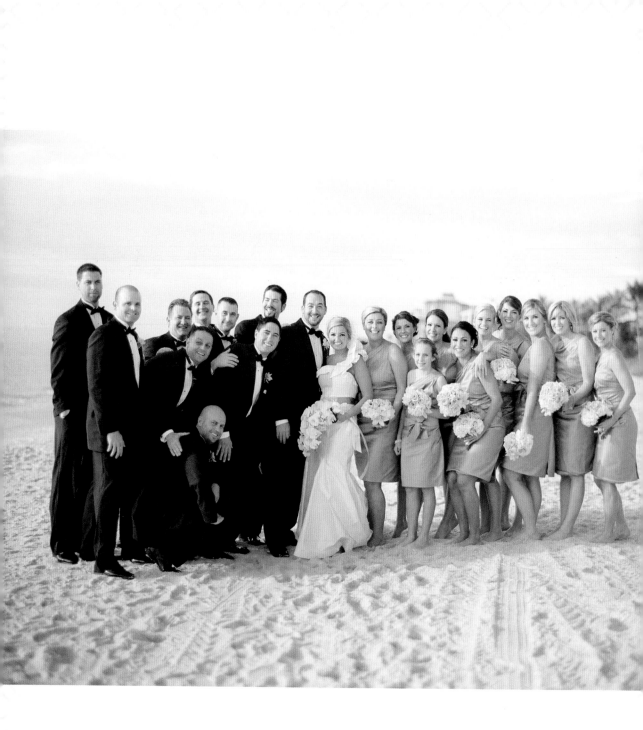

the bare(foot) minimum

When photographing a wedding party with a more casual, freewheeling vibe, match their tone with this oh-so-casual barefoot portrait. Ask the bridal party (or at least the ladies) to remove their shoes and come together as closely as possible. Place the bride and groom in the center of the group, and then pile the girls and guys in from the sides, making sure everyone can see the camera without blocked faces. Minimal direction will leave room for more fun and natural interaction. After this frame, zoom in to focus on the ladies' bouquets or their bare feet in the sand.

TIP Find out what's important to your couple in initial conversations, and scout locations they'll love that aren't far from the venue or are en route from the ceremony site to the reception spot. Couples with an affinity for the beach or a lake likely won't mind detouring their bridal party transportation by fifteen minutes for a few pictures. (Beach images also mean less cropping out of buildings and other distractions.)

Bright afternoon sidelight required turning these subjects away from the sun as much as possible to avoid light shining in their eyes.
80mm Zeiss lens, Fuji Pro 400H, f/2 for 1/500 sec., ISO 200
Photo by KT Merry

en vogue

A black-and-white finish complements luxe décor, long gowns, and classic hairstyles, making the elegant bride and party look as though they've stepped out of a fashion magazine. Place the bride slightly closer to the camera and arrange the ladies in varied positions—some sitting, some standing—but all on the same level of focus. The variety in poses and amount of space between individuals adds interest and keeps the eye moving through the composition. Next, zoom in tighter to frame each of the ladies in turn.

TIP Dress appropriately and professionally: know ahead of time what to wear in order to fit in and not distract from the event. Sensible, stylish shoes are a must.

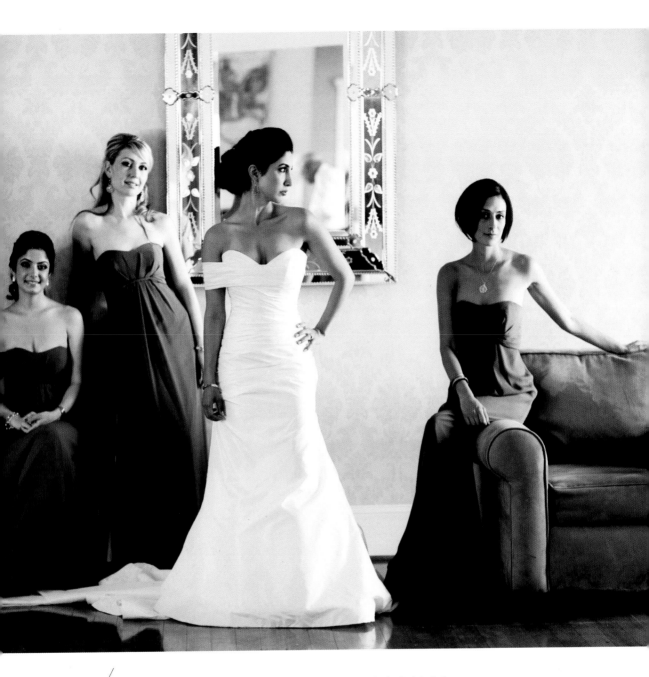

Light from a window at camera right and another light behind the
photographer lends to this moody, editorial capture.

85mm F2.8 lens, f/1.2 for 1/160 sec., ISO 1600

Photo by Anna Kuperberg

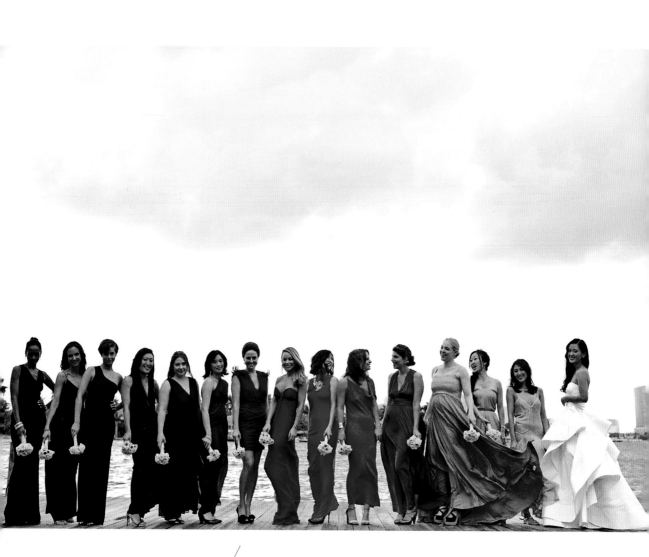

On this overcast day, clouds lent even lighting, while sand and a
weathered boardwalk bounced light onto the subjects.
35mm F1.4 lens, f/3.5 for 1/500 sec., ISO 320
Photo by Our Labor of Love Photography

skyward

Capturing a beautiful sky in portraits not only lends to a dramatic image but also shows the weather the day of the wedding. Place everyone on a platform or walkway with the bride at one end and everyone facing in toward the center, move far back, and shoot upward for a backdrop of sky (and to reduce building clutter). Avoid overly posing subjects; just line up the shot and capture them talking and smiling. Let the ladies drop their bouquets to their sides, adding to the casual feel. Typically, the most genuine and flattering moments occur when the bridal party thinks photographers aren't ready to take their picture yet.

TIP When you have dark clouds available to lend a moody, delicious backdrop to your image, keep your flash off and meter for the subjects without blowing out the sky.

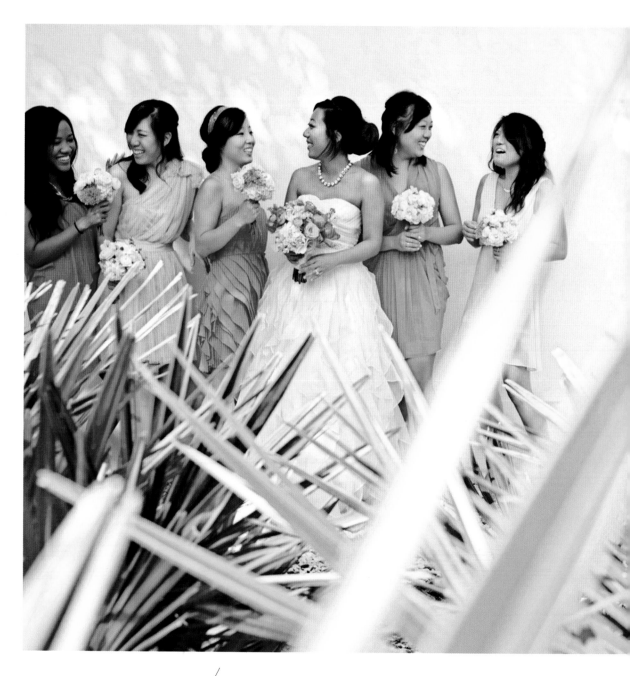

On this bright, sunny afternoon, the subjects were assembled
near a wall directly under a thin shadow cast from above.
50mm F1.2 lens, f/2.8 for 1/500 sec., ISO 200
Photo by Heidi Geldhauser with Our Labor of Love Photography

shooting through

Photographing through trees, plants, or flowers adds depth and framing for a more artistic result. Get low and frame your shot through the foliage. Then, group the bride and bridesmaids together, arranged in pairs, and ask them to talk together for a giddy moment. Next, have the ladies walk, single file, toward the right or left side of the frame, capturing movement and candid expressions.

TIP One way to ensure delicious pops of color in an image is to shoot against a white backdrop. This creates a blank slate that emphasizes the bright color worn by the bridesmaids and contrasts it with the bright green foliage.

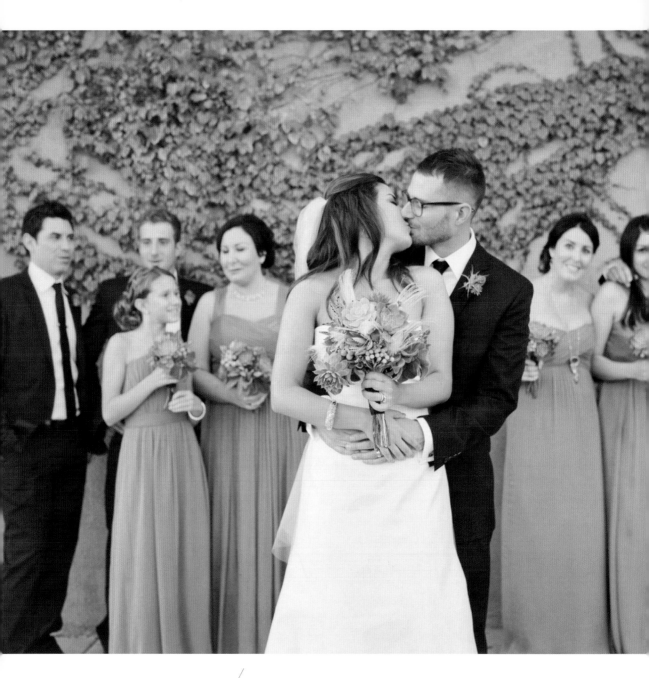

For this capture, taken toward the end of the
day, low light required increasing the ISO.
35mm F1.2 lens, f/2.2 for 1/400 sec., ISO 1250
Photo by Heidi Geldhauser with Our Labor of Love Photography

focus group

Here is a great pose to try after you've taken a more standard group portrait. Keeping the wedding party in position, ask the couple to move forward, creating distance between them and the rest of the group. Change to a shallow depth of field so that the couple is sharp while the group is out of focus. Ask the party to make the couple laugh, suggest a kiss, and click away. This kiss can be followed by a hug, a glance at the camera, and the group walking up to join the couple.

TIP Depth is your best friend when you need to take a variety of images in a tight time frame. Leaving your subjects in place and letting them interact naturally, simply vary your camera's f-stop for shallow depth-of-field details, such as on bouquets and pops of color, as well as deep depth-of-field wide shots.

stair apparent

If your venue has a set of wide stairs, here is a fresh, interesting grouping to make the most of them. Place the bride and groom in the foreground; then layer the bridesmaids and groomsmen symmetrically on the steps behind the couple, being careful not to place all of them on the same steps and making certain you can see everyone's faces. Stand at eye level a few yards away, focusing on the bride's eyes. Next, group everyone more closely for a tighter shot; then try altering heights by instructing some members to stand and others to sit.

TIP Don't have stairs to work with? A slight hill at the venue can accomplish a similar, staggered effect.

Shooting in cloud cover is pleasant, since full sun can create harsh shadows and result in closed eyes.
50mm F1.2 lens, f/8 for 1/125 sec., ISO 800
Photo by Heidi Geldhauser with Our Labor of Love Photography

off-center
of attention

Although the bride and groom are the center of the big day, it's an interesting change to place the couple off-center in a few photographs. Guide the group to a small, well-lit space (like the path shown here), place the bride and groom at the edge of the frame, and see where the rest of the wedding group naturally places themselves. When working with a larger wedding party, ask a couple of the younger guys to squat in the front row to create dimension. Kneel down to photograph from a low angle. Once the party is free to move from this location, continue shooting for more unprompted captures.

TIP Always snap plenty of pictures of each pose to ensure some without eye blinks.

Taken about an hour before sunset in open shade, this image is filled with backlight and loved ones.
85mm F1.4 lens, f/2.5 for 1/1000 sec., ISO 200
Photo by Paul Johnson Photography

guys being guys

Find a decidedly masculine wall or background near the wedding venue, such as this gritty spot under a bridge, and line up the gentlemen of the bridal party. Using a long lens, stand back until you can frame them all in the shot and say, "Show me your coolest pose." Point at one or two of them doing it right to bring out the group's competitive nature. Declare winners of the "best cool pose," and snap a handful of great captures from the side while the guys goof around and egg each other on.

TIP Almost every groom wants photos with his groomsmen, but few groomsmen actually want to be in photos. Work fast, and keep things simple and loose.

Capturing this image just beneath a bridge created nice light and interesting shadows.
85mm F1.2 lens, f/4.5 for 1/250 sec., ISO 1600
Photo by bobbi+mike

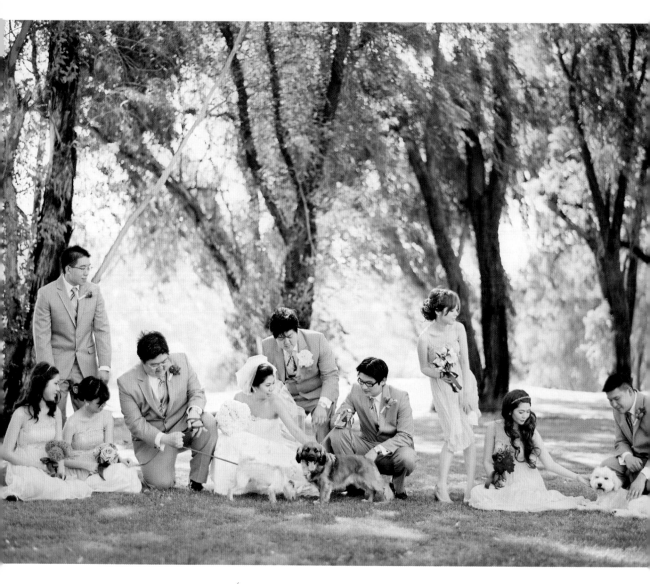

Towering trees offer open shade,
sprinkling diffused light onto these subjects.
80mm Zeiss lens, Fuji 400H 220mm film, f/4
for 1/250 sec., ISO 400
Photo by Jen Huang Photography

the element of fun

Position wedding party members on different levels, and then encourage them to interact with a fun prop or element, whether it's the couple's dog, as here, or a bench, swing, fountain, or other natural or architectural feature. Position each subject so as to create a classic triangle pose (three small triangle poses are shown here, each with three or four subjects), asking each person to sit, kneel, crouch, or stand. Once they're in position, ask them to visit within their small groups softly and ignore your camera. Next, tighten the frame to capture each smaller group separately.

TIP Many couples today are including their dogs on their wedding day. Be creative when incorporating these fun family members, whether the dogs are on a leash, sitting, or interacting with the bride and groom or the flower girl. Keep a few treats in your pocket; when you want the dog's attention, hold the treat over the lens.

in-between moments

Normally, there will be some sort of walk involved to get the wedding party to the spot you have preselected for their portraits. Why not take advantage of this transition for some dynamic, motion-filled images? Ask the bride and groom to walk ahead of the others, and running ahead, use the walking group as a frame for direct shots of the couple kissing as they walk. After the couple comes away from their kiss, follow up with a vertical shot of them looking happy, with their eyes focused on their destination.

TIP Given that most bridal gowns are white, you might find that your camera wants to compensate for all that white, consequently underexposing the dress. For a quick fix, try using your exposure compensation to open up your exposure and keep that dress properly white.

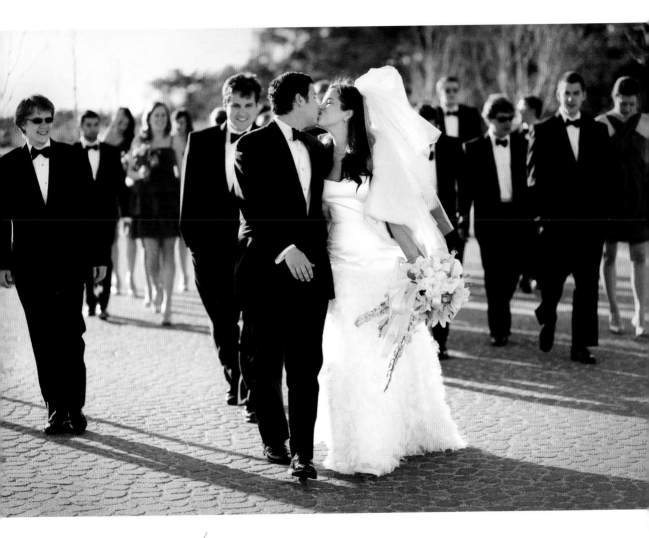

Sunshine from camera left casts long, sumptuous
shadows on the textured walkway.

85mm F1.4 lens, f/2.8 for 1/1600 sec., ISO 200

Photo by Paul Johnson Photography

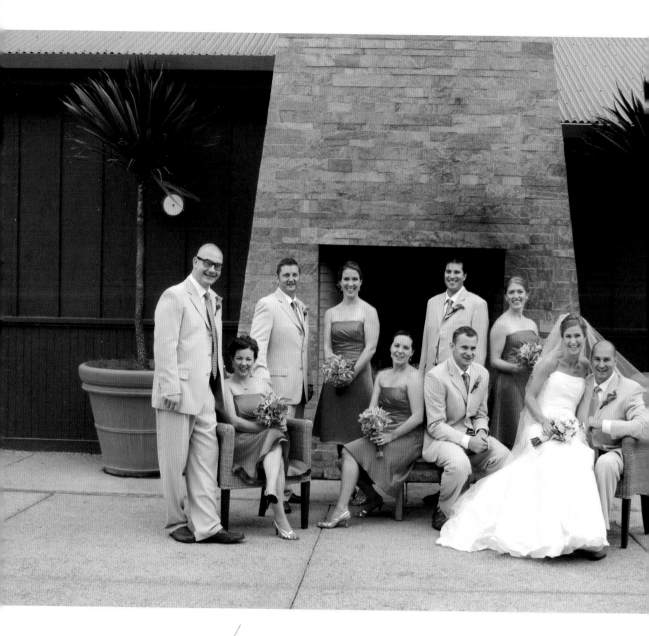

Open shade on the side of this building combined
with evening light to help set the scene.
24mm F1.4 lens, f/13 for 1/125 sec., ISO 400
Photo by Anna Kuperberg

mixed doubles

Here's another way to shake up a traditional wedding party portrait. Starting with a fairly conservative grouping as a base, mix it up ever so slightly by setting off people in pairs to create interesting visual contrast between the dresses and suits. Arrange chairs in front of a plain wall, fabulous focal point, or centerpiece; then place the bride and groom first, the groom seated and the bride in his lap. Arrange the others in pairs, making an effort to balance your composition and not repeat exact poses.

TIP Allow time for family members and friends to snap pictures of the wedding party, too, but always after you go first. This demonstrates your leadership and keeps would-be shutterbugs at bay when you need to focus.

walk the line

Whether captured on a pier, at a crosswalk, or across a lawn—anywhere you can crouch low and get a clean background—having subjects walk in a line provides a unique way to catch everyone in the wedding party. Space each member of the wedding party out evenly, and get far enough away to capture everyone in your frame. Direct them to walk, making sure they move slowly so that you don't have to reshoot the scene. For another fabulous frame, put the bride and groom at the front of the line and have them kiss, with the other bridal party members reacting down the line.

TIP Since getting a large group of clients into position can be challenging and time-consuming, once you have a strong start, keep them in place and make simple changes to your position to collect different angles and views.

Sunlight from behind turned the water
below into a luscious shimmer of light.
17–35mm F2.8 lens, f/6.3 for 1/320 sec., ISO 100
Photo by Anna Kuperberg

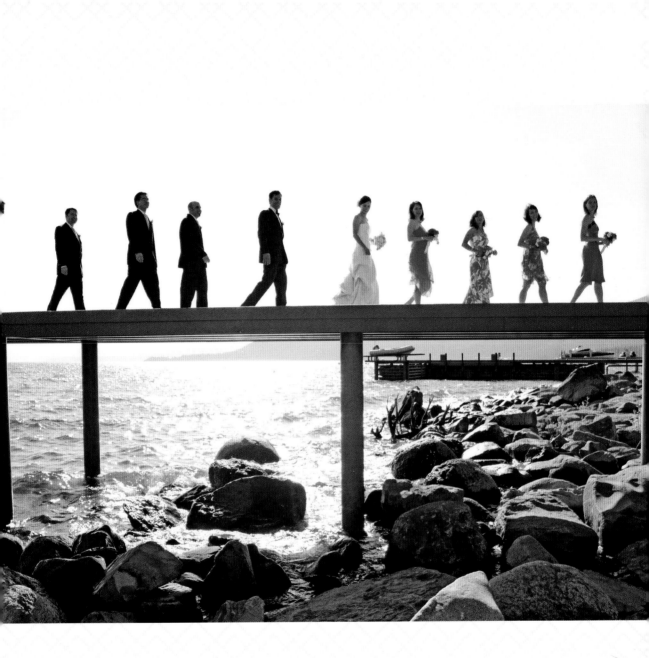

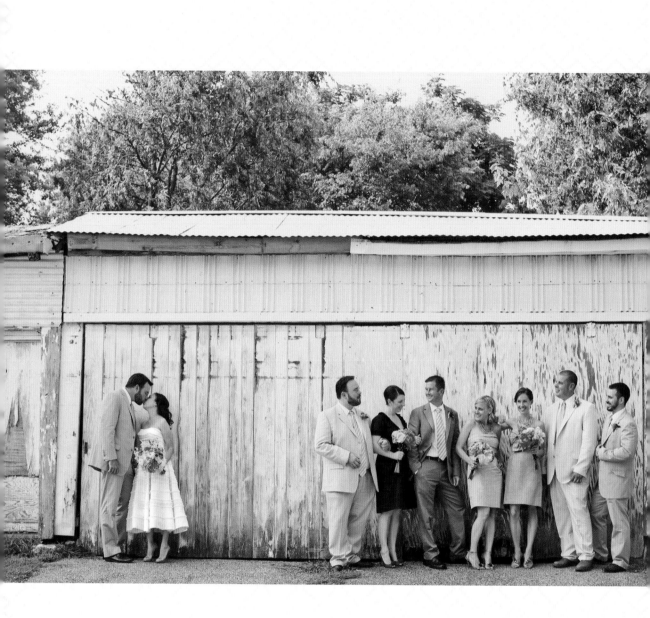

spaced out

This image allows the wedding party to largely pose themselves, with some photographer suggestions here and there. Position groups very close together—closer than they would naturally fall into place. Then instruct the group as a whole to do the following, photographing each one: look at the camera, look at each other, hold hands, while you ask the couple to hug or kiss. Follow by asking the wedding party and bridal couple to face one another; then leave the couple in place but ask the party to face the camera.

TIP When posing a group, ask subjects to turn slightly in toward the center, as a slight profile capture is always more flattering than a straight-on one. Another posing tip is to have them bend their arms, as bent arms are more flattering than straight arms.

In this photo, taken in the shade of the barn, the asphalt reflected natural light onto the subjects, illuminating their faces and adding highlights, while the white background also reflected light back onto the group.
50mm F1.2 lens, f/5 for 1/400 sec., ISO 400
Photo by Heidi Geldhauser with Our Labor of Love Photography

tightly knit

Get the bride and bridesmaids to gather in tight for a capture of a fun, close-knit group of girls. Vary poses, heights of bouquets, even the direction of their slight leans, and then ask a few of them to turn. Use open-ended posing instructions—such as asking for their best "cute and sassy" looks—so that each woman displays her own unique personality. Say something ridiculous, and capture the resulting great expressions. For even more marvelous moments, frame details of their shoes and flowers.

TIP Give plenty of positive praise to your subjects as you work. When the wedding party feels confident, not only does their body language show it but morale tends to remain high for the rest of the session.

These spirited sweethearts were photographed in open shade on a very sunny afternoon.
35mm F1.4 lens, f/3.5 for 1/500 sec., ISO 100
Photo by bobbi+mike

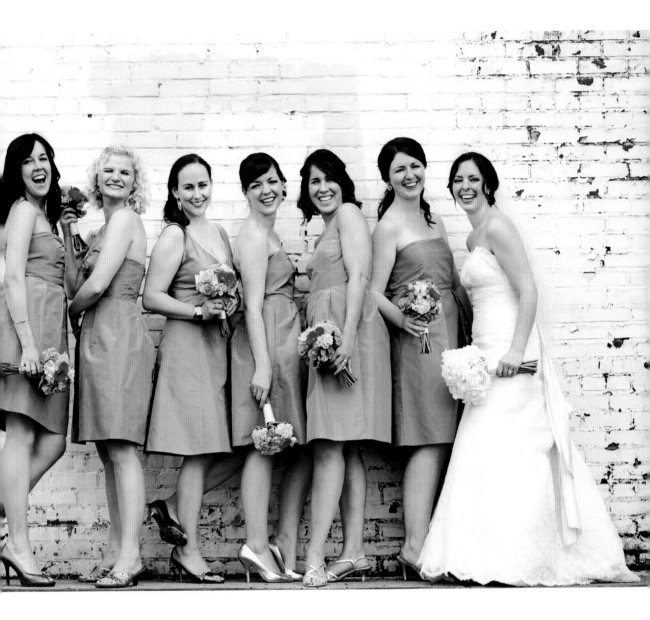

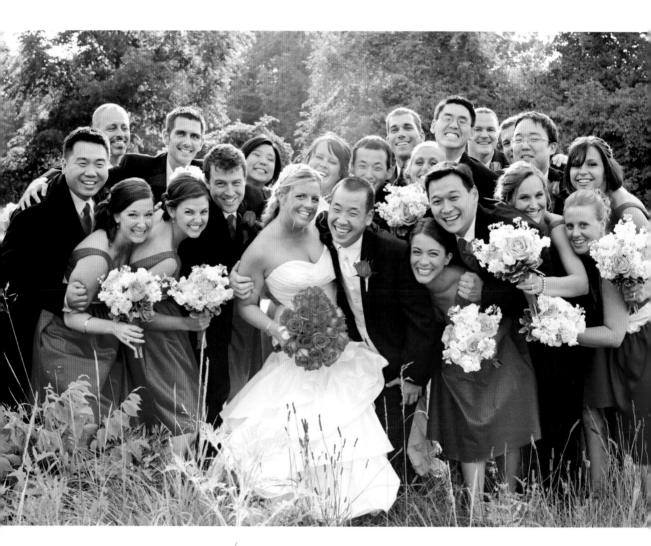

This colorful capture was taken in the afternoon while the
sun was still fairly high in the sky, with backlighting against
a tree line presenting the best scenario for illumination.
50mm F1.2 lens, f/8 for 1/320 sec., ISO 640
Photo by bobbi+mike

fun & fancy free

For this wonderfully imperfect pose, place the bride and groom in the foreground and the wedding party in the background. Ask the party to group hug the bride and groom, lean in, and say, "1 …2 …3 …honeymoon!" Make sure each person can see your camera. Having them hunch in and together might feel a little like they are being squished, but the physical closeness lends to a feeling of actual closeness as well as some fun—and sometimes funny—candid moments.

TIP If it's uncomfortably hot, cold, or rainy outside, say something like, "We're going to move as fast as we can so that we can get you back inside!" From that point forward, the wedding party will move quickly because they'll know you're looking out for them.

away we go

After capturing the bridesmaids all together from the front, ask them to turn around, put their arms around one another, and slowly walk away from the camera, with heads looking forward for good posture. Here, the bride is visually closer to the camera, and the bridesmaids angle out to the sides in a subtle V formation. Make sure to angle their bouquets slightly toward the camera to pop against the beautiful bridesmaid dresses. Often when you tell bridal parties they are done, they will relax for a great candid shot.

TIP When you're looking for unity in a group pose, the less visual space between the bride and her bridesmaids, the better.

Open afternoon shade with soft backlight from the sun created this open, airy scene.
80mm Zeiss lens, Fuji Pro 400H film, f/4 for 1/500 sec., ISO 200
Photo by KT Merry

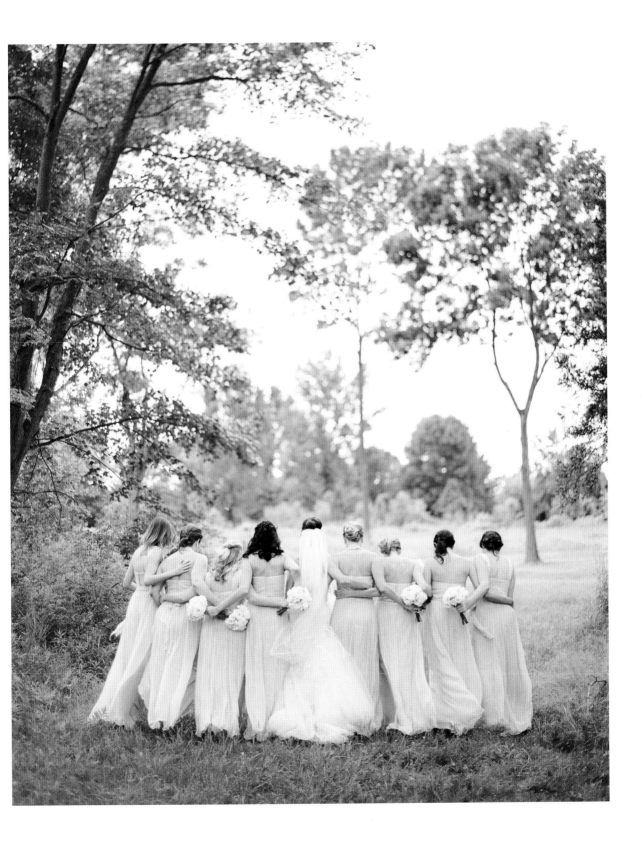

parting thoughts

Weddings provide both a challenge and an opportunity to document the beginning of a new chapter in life. When captured with care and an eye toward natural posing and thoughtful composition, wedding portraiture can be a beautiful expression of timeless love. We hope you will take the inspirations shared in this book and apply them in a way that speaks to you, as you create and collect moments that will become your subjects' future heirlooms and most prized possessions.

Continue to grow as an artist, mastering your camera's technical abilities and then moving beyond concerns of aperture and shutter speed so that you can focus on the art of storytelling and the craft of documenting an intimate relationship between two individuals and their friends and families.

Most important, have conviction in your craft, and never lose sight of what sparked your interest in documenting the shared moments of others. The beauty you capture will become part of a catalogue of memories that will be revisited for generations.

Photo by Elizabeth Messina Photography

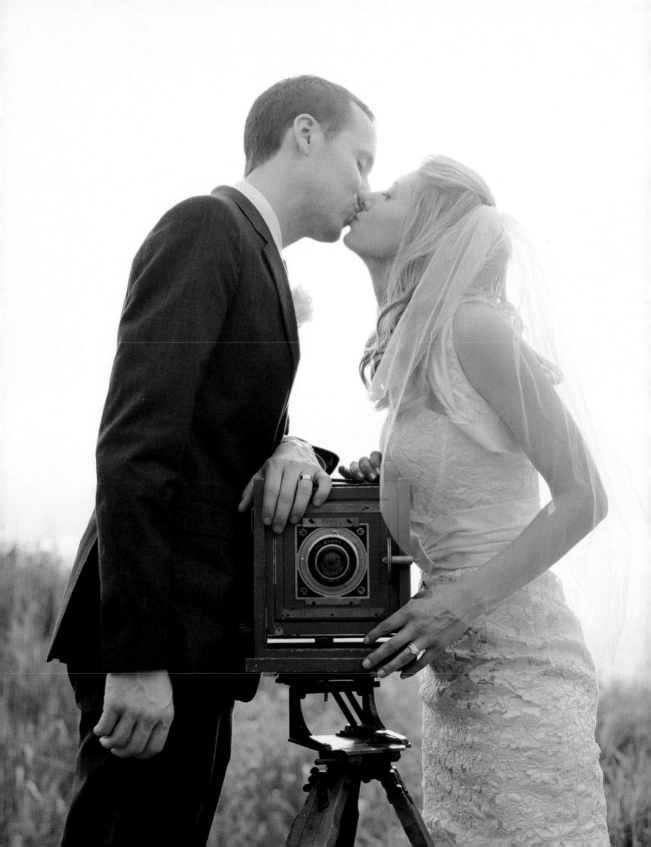

meet the photographers

KAT BRAMAN, of Kat Braman Photography (katbramanphotography.com), has photographed weddings all over the country, as well as in Europe and New Zealand. She works primarily with film and combines timeless documentary coverage with quirky, fun, fresh portraits. Her photography has been featured on such websites as Style Me Pretty, Junebug Weddings, 100 Layer Cake, and Rock 'n' Roll Bride. *Photo by Jessica Lorren Organic Photography*

JESSE AND WHITNEY CHAMBERLIN, of Our Labor of Love (ourlaboroflove.com), believe that family celebrations, friends, and true love are beautiful and that any images representing these milestones should share the joy. They often explore the world—cameras in hand—with their two children by their side. *Photo by We Are the Rhoads*

While studying drawing at the Atlanta College of Art, HEIDI GELDHAUSER met Jesse Chamberlin and, in 2005, joined the team of Our Labor of Love (ourlaboroflove.com). When not taking photos, Heidi thoroughly enjoys drinking coffee and editing while listening to NPR podcasts. Other distractions include drawing, painting, working on her documentary, and participating in what is arguably the coolest book club ever. *Photo by Jennifer Emerling Photography*

JEN HUANG, of Jen Huang Photography (jenhuangphotography.com), approaches photographing weddings with a romantic, fine art sensibility and a passion for medium-format film. Known for her fresh, luminous portraits, Jen crafts beautiful, editorial images for everything from intimate soirees to splendid outdoor weddings. Her work has appeared in bridal publications all over the country. Jen lives in New York City with her husband and their French bulldogs, Gatsby and Pepper. *Photo by Robert Sukrachand*

PAUL and MECHEAL JOHNSON of Paul Johnson Photography (pauljohnsonphoto.com) split time behind the camera capturing weddings, families, and individual portraiture. Though Paul was a photographer before he met his wife, Mecheal (he shot his first wedding at age twelve), they have been shooting together since their first joint wedding in 1996. Their work has appeared in *Wedding Photography Unveiled* as well as *Southern Weddings and Brides* magazines. In addition to shooting in and around their home base of Rosemary Beach, Florida, Paul and Mecheal travel often for their clients, whether to Scotland, Mexico, or the Bahamas. *Photo by Laura Johnson*

ANNA KUPERBERG, of Anna Kuperberg Photography (kuperberg.com), is a wedding, family, and dog photographer based in San Francisco. Her work has appeared in *InStyle*, *People*, and *Martha Stewart Weddings* magazines, has been exhibited nationwide (including a solo show at the St. Louis Art Museum), and is in the permanent collections of the Philadelphia Museum of Art, the St. Louis Art Museum, and the Portland Art Museum. *Photo by John Riedy Photography*

Based in San Francisco, LISA LEFKOWITZ, of Lisa Lefkowitz Photography (lisalefkowitz.com), has spent the last twelve years specializing in fine art film photography and has earned national recognition for her fresh lifestyle images. Lisa's work has appeared in such publications as *Martha Stewart Weddings* and *Bride*, and on the website Style Me Pretty as well as on the cover of *PDN*'s Wedding Issue. She has also been featured in an ad for Fujifilm. *Photo by Lisa Lefkowitz Photography*

TANJA LIPPERT, of Tanja Lippert Photography (tanjalippertphotography.com), is a film photographer who specializes in weddings, fashion, commercial, music, and fine art photography. When not traveling worldwide for assignments, she resides in California. Tanja loves adventure, creativity, spontaneity, and inspiring others and admits to being a bit of a dreamer as well as a hopeless romantic. *Photo by Tia Reagan*

Photography has always been important to JESSICA LORREN, of Jessica Lorren Organic Photography (jessicalorren.com). From her earliest memories, she was drawn to photographs and the unique way they frame our world. Since 2008, she has relished building solid relationships with clients, spending some of the happiest events of their lives with them, and creating meaningful imagery that captures these moments and preserves them forever. *Photo by Jamie Clayton*

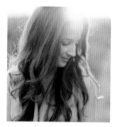

KT MERRY, of KT Merry Photography (ktmerry.com), is a fine art wedding photographer specializing in destination weddings worldwide. Trained at the Hallmark Institute of Photography and with a background in fashion photography, she brings a soft, artful approach to wedding photography. She has been featured in publications such as *Martha Stewart Weddings*, *Brides*, *The Knot*, *ELLE*, and *Modern Bride*. KT is currently based in Miami and seasonally in California. *Photo by Jose Villa*

ELIZABETH MESSINA, of Elizabeth Messina Photography (elizabethmessina.com), is an award-winning photographer, author of *The Luminous Portrait,* and the happily married mother of three beautiful children. Her innate sense of style is reflected in her images, which grace the pages of countless magazines. Elizabeth's work takes her around the world, but a piece of her heart always remains with her family. Their home in Southern California is filled with laughter, laundry, kisses, and photographs . . . lots of photographs. *Photo by Elizabeth Messina Photography*

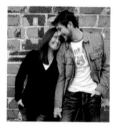

Ever since leaving their promising careers in graphic design and aviation, BOBBI SHERIDAN and MIKE BELSCHNER, of bobbi+mike photographers inc. (bobbiandmike.com), have quickly attracted a following with their easygoing, energetic style and memorable brand. They pride themselves on continually pushing their own expectations, never treating photography like it's just a job, and they know that the perfect shot shouldn't come at the expense of clients having a good time. *Photo by SB Childs Photography*

CAROLINE WINATA, of Milou + Olin (milouandolin.com), is a classically trained artist with a free-spirited, bohemian, fashionably editorial, romantic style. With an adventurous and gorgeous mix and match of concepts—from bold and fun to feminine and beautiful—her photographs show an authentic interest in her clients as well as a love for the world and the people within it. In addition to her addictions to friends, fashion, big cocktail rings, and her award-winning Portuguese water dog, Milou, Caroline loves to obsess over design, finding happiness in obscure moments, stumbling upon beautiful light, and meeting new people, preferably over decadent sashimi. *Photo by Photobolic*

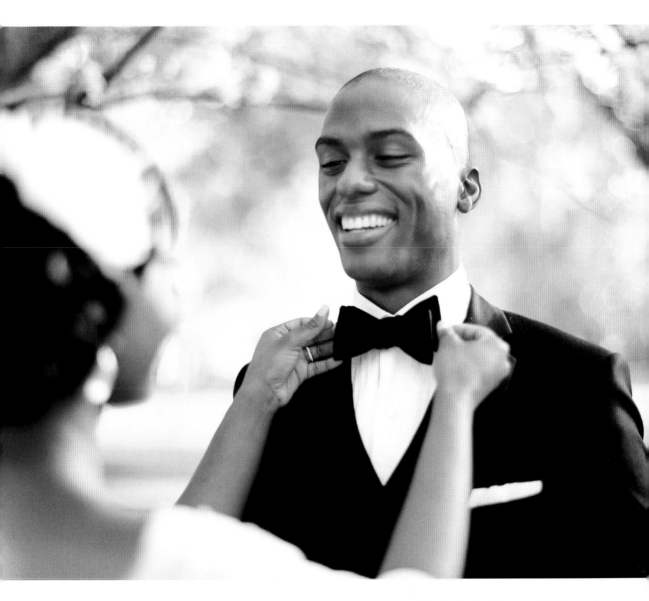

Photo by Jen Huang Photography

index